D1360070

Dale Chihuly

BY WILLIAM WARMUS

THE WONDERLAND PRESS

Harry N. Abrams, Inc., Publishers

THE WONDERLAND PRESS

The Essential™ is a trademark
of The Wonderland Press, New York
The Essential™ series has been created by The Wonderland Press

Series Producer: John Campbell
Series Editor: Harriet Whelchel
Project Manager: Adrienne Moucheraud
Series Design: The Wonderland Press

Library of Congress Catalog Card Number: 99-69224
ISBN 0-7407-0729-9 (Andrews McMeel)
ISBN 0-8109-5812-0 (Harry N. Abrams, Inc.)

Copyright © 2000 The Wonderland Press
All works by Dale Chihuly © 2000 by Dale Chihuly
All images courtesy Chihuly Studio
Any previously published material in this book is derived from
copyrighted material by Dale Chihuly, Chihuly Inc., Portland Press
or William Warmus, and is used herein with permission of the owners

Published in 2000 by Harry N. Abrams, Incorporated, New York
All rights reserved. No part of the contents of this book may
be reproduced without the written permission of the publisher
Distributed by Andrews McMeel Publishing
Kansas City, Missouri 64111-7701

On the end pages: Detail from *Fiori di Como*, 1998, Bellagio Resort, Las Vegas, Nevada

Printed in Hong Kong

Harry N. Abrams, Inc.
100 Fifth Avenue
New York, NY 10011
www.abramsbooks.com

PHOTOGRAPH CREDITS: Philip Amdal: 71; Theresa Batty: 53; Dick Busher: 20 (bottom); Eduardo Calderon: 75; Shaun Chappell: 4, 66-67; Edward Claycomb: 32; George Erml: 111; John Gaines: 61; Claire Garoutte: 14, 21 (top), 40, 51, 62, 73, 94 (bottom); Russell Johnson: 8, 20 (top), 22, 24, 25, 68, 82, 88, 94 (top), 106; Mary Laurence: 59; Terry Rishel and Teresa Rishel: 41, 54, 57, 93, 95, 98, 99, 100, 101, 104, 107, 108, 112; Roger Schreiber: 33 (left), 42, 52; Chuck Taylor: 11, 13

Contents

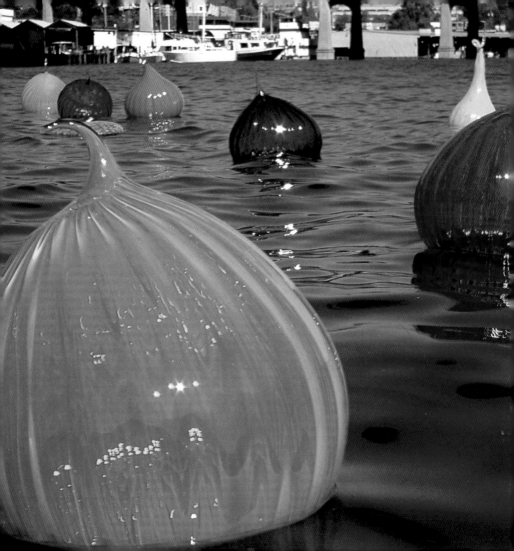

Bring on the Magic!

In mid-1999, a Washington lawyer attended a meeting with President Clinton in the personal quarters of the White House. As they exited, the men passed a Dale Chihuly glass sculpture that is a centerpiece of the White House collection. When the president learned that the lawyer was a collector of Chihuly, he exclaimed, without missing a beat: *"That Chihuly! What a character be is!"*

Sound Byte:
"One of my favorite artists is Harry Houdini. Maybe that's what I'm trying to be—a magician."

—DALE CHIHULY, 1996

It's rock-'n'-roll Time

Who is this art-world outsider with paint-splattered shoes who makes millions with his sensuously beautiful works of art? What do we know about this genius-madcap-pirate from Tacoma who built **Chihulyland**, a fabulous home base from which he plans ever-more ambitious adventures? How can we explain this Olympian force who

OPPOSITE
Walla Wallas
1996
Lake Washington
Ship Canal
Seattle
Washington

roams the world with his team of glassblowers and mesmerizes huge crowds with awesome installations?

Meet Dale Chihuly, the wild-haired Merlin behind the magic whom *People* magazine has called "the most famous glass artist since Tiffany" and whom the *Robb Report*, a magazine devoted to luxury living, named the most collectible artist of 1999. His work is known for its:

- exuberant **colors**

- **exotic shapes**, ripples, squiggles, and undulating lips

- **dramatic scale**, ranging from the dainty to the mammoth

- unusual placement or **configuration** within smaller "sets" or larger installations of sculptures

- progressive **evolution of styles**, from the *Navajo Blanket Cylinders* (1975) to the *Baskets* (1977), *Seaforms* (1980), *Macchias* (1981–83), *Persians* (1986), *Venetians* (1988), *Niijima Floats* (1991), *Chandeliers* (1992), the sets for *Pelléas et Mélisande* (1992), *Chihuly Over Venice* (1996), *Chihuly in the Light of Jerusalem 2000* (1999–2000), *Chihuly Jerusalem Wall of Ice* (October 1999), and beyond.

Maestro of the molten

Close your eyes for a moment and visualize a work of art that is made, not from such time-honored materials as bronze or oil paints, but from fragile glass, ice, or water. Suppose that this art doesn't behave like art either—that it glows molten hot, depends for its existence upon the breath of an artist, and thrives not only inside museums but also under the desert sun or immersed in the vast waters of the ocean.

Come inside the world of American artist Dale Chihuly and stand next to him at work in Seattle with his colleagues as they sweat to shape 100 pounds of molten glass, forming it into an amazing floating sculpture ready to be launched into the ocean. Travel with him in 1996 to Venice, where he installs 14 dazzling assemblages of highly colored blown-glass *Chandeliers* that hover delicately above the Venetian canals and gondolas or within the palazzos, flaring in the sunlight or glinting in the candlelight—a spectacular ornamentation perfectly adapted to that theatrical city. Join him for tea with Queen Elizabeth II of England or tag along while he hobnobs with Hollywood celebrities.

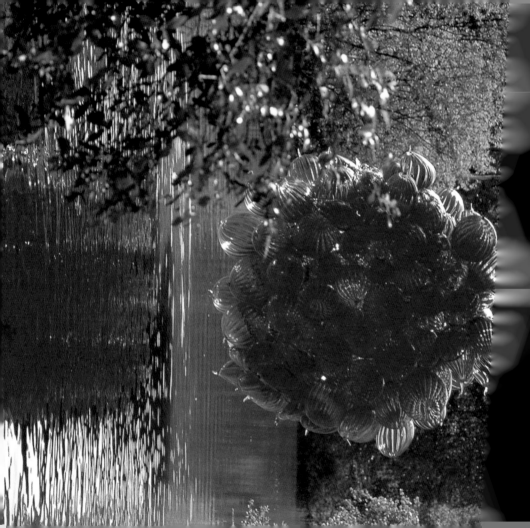

From the Earth to the Heavens

The mystery of Chihuly's art becomes all the more exciting when you consider that he works with glass, an industrial material—made from sand and as common as car windshields and lightbulbs. Yet in Chihuly's hands, glass becomes *outrageously original.*

Plain and simple, the artist's goal is to transform the world through the hypnotic beauty of his art. Just as the artist **Louis Comfort Tiffany** (1848–1933) sought to have an impact on the taste of every town, church, and home in America with the revolutionary design of his glass windows and lamps, Chihuly is intent on filling every city and museum with his hypnotic art. In fact, the term "Chihuly style" can be defined as *a total focus on the pursuit of beauty,* to the exclusion of all else—an intensely emotional and aesthetic quest, with no intellectual content or intent to create meaning.

Pirate on the prowl

Spend a few minutes with the endlessly curious Chihuly and you'll see that he's likely to ask your opinion of his most recent project, or invite you to compare the headlines in *The New York Times* with those of *USA Today,* or inquire about the best place to find old Frisbees for his collection. He wears a black patch to cover an eye that was damaged years ago in an automobile accident, and his paint-splattered shoes are

OPPOSITE
Cadmium Red
Basket Set, 1997
37 x 24 x 18"

a familiar sight in the art world. **Henry Geldzahler** (1935–1994), former curator of contemporary art at The Metropolitan Museum of Art in New York, once said that the striking Chihuly "looks like a pirate and sometimes acts like a pirate," leading the life of a nomad and traveling the world over to orchestrate museum shows, glassblowing sessions, and installations of his work.

He has changed the way we think of art by moving it from inside the world of museums to the outside, external world of natural and urban settings. There, he challenges the art under the most demanding circumstances, then returns it to the interiors of museums and private collections, freshly energized and with an aura of triumphant *arrival*. It's as if his creations, once they've been through a marvelously exotic journey, are now ready (and eager) to be seen by viewers.

Sound Byte:

"Chihuly's work is American in its apparent vulgarity, its brazenness, and its fearlessness to move farther out west even if there is no farther west to move to. There's a kind of pioneering spirit to it.… In Chihuly's case, exuberance shouldn't be confused with happiness. He has his moods, and he especially seems to need to go away and come back. I think it is then that he revitalizes himself."

—HENRY GELDZAHLER, former curator,
The Metropolitan Museum of Art,
New York, 1993

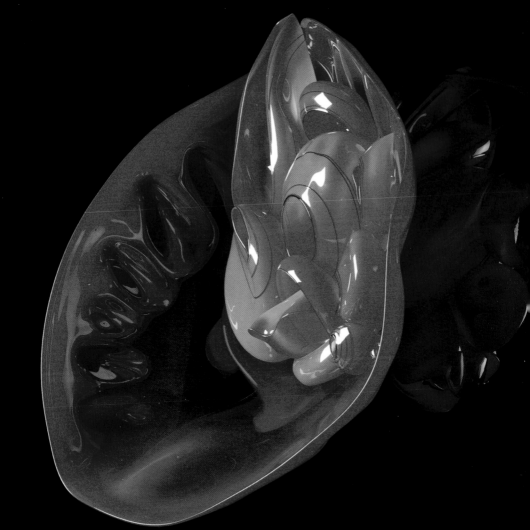

Dale in 1942
Tacoma
Washington

Blue-collar roots

Long before Microsoft, Amazon.com, and Starbucks became havens for innovators in the Pacific Northwest, a vast, junglelike forest covered the wild Pacific Coast, lined with active volcanoes and ice-shrouded slopes that melted into streams crowded with salmon. Dale Chihuly, whose artwork owes everything to fire, ice, and water, was raised on the edge of this paradise.

Born on September 20, 1941 (a Virgo!), in Tacoma, Washington, Dale Patrick Chihuly is the son of working-class parents **Viola Magnuson** (b. 1907) and **George S. Chihuly** (1907–1958). Tacoma was then a lumber center and shipping port overshadowed by nearby Seattle. George Chihuly, a butcher and a union organizer, could intimidate anyone, but, according to Dale, *never got in a fight*. Proud of his resemblance to George, Dale now claims to *walk loudly, but with no stick*.

George Chihuly was of Czech, Hungarian, and Slavic stock, while Viola's family was Swedish and Norwegian. As we'll see, the powerful Czech and Scandinavian glassmaking cultures would later play a significant role in Chihuly's growth as an artist.

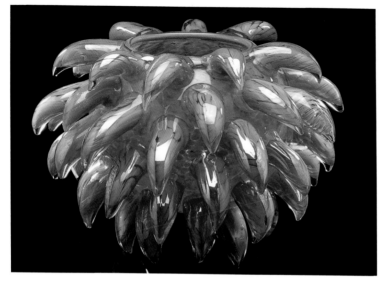

*Rose Venetian
with Rose and
Gold Prunts*
1989
11 x 14 x 13"

And so the story begins: As a child, Dale takes long walks along the beach with his family, seeking out the shiny, sea-polished bits of glass that have washed ashore. At Christmas, when Chihuly is ten, he helps to decorate his family's home with **glass ornaments** inside and **glass lightbulbs** outdoors. The youngster first discovers his entrepreneurial streak when he begins selling Christmas wreaths door to door.

As a teenager, he charges admission to card games that he organizes in his mother's basement. It's not surprising that his report cards list more days absent than present, and the unorthodox boy is arrested several

times, most notably for throwing a brick through a cop-car window and inciting a disturbance. When asked if this window-shattering incident was his first "work" with glass, he says no, that first he broke streetlights as a kid!

A double Tragedy

In 1957, tragedy strikes while Chihuly is a sophomore at Stadium High School in Tacoma. On April 23, his 21-year-old brother, **George W. Chihuly**, an aviation cadet, is killed in a Navy Air Force training accident. A later photo shows Dale with the Austin Healey sports car that George had bequeathed to him—the beginning of the artist's love of sports cars and collecting.

Tragedy hits again several months later when Dale's father—devastated by his son's death—suffers a fatal heart attack at age 51. Chihuly's mother, Viola, a homemaker and avid gardener, goes to work as a waitress to support herself and Dale, and from this moment on she becomes the guiding force in his life.

When Chihuly graduates from high school in 1959, he has no interest in pursuing his education, but his mother convinces him to enroll in the College of Puget Sound in Tacoma. Dale is the first in his family to attend college.

OPPOSITE
Venturi Window
1992
48 x 16 x 7'
Seattle Art Museum
Seattle
Washington

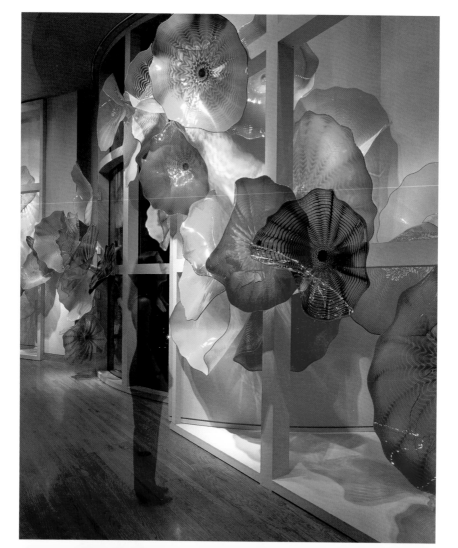

Sunflowers anyone?

In 1960, Chihuly discovers an interest in art while researching a term paper on Vincent van Gogh. The same year, he remodels a small den in the basement of his mother's home and finds that he enjoys working with objects and crafting the shape of his environment—talents that will find expression in the ambitious glass installations that he will later create. Before long, he transfers to the University of Washington in Seattle so that he can study interior design and architecture.

In 1961, he is made rush chairman at Delta Kappa Epsilon fraternity, an "honor" he later regrets because it turns him into a party animal. After neglecting his studies, Chihuly drops out of college in 1962 and travels to Florence, Italy, to immerse himself in art. Increasingly depressed and frustrated because of his inability to speak Italian, he leaves for Paris—without being able to speak French, either!—and, subsequently, for the Middle East.

Middle-East awakening

By 1963, Chihuly finds himself working on a kibbutz in the Negev Desert, in Israel, where one of his duties is to patrol the militarized border adjacent to Jordan. One night, while alone and without the support of friends or family, Chihuly sees "the light in the desert": The kibbutz helps him to realize the value of having focus in his life,

a relief from the aimless veering between pool halls and bowling alleys where he had wasted his time while attending the University of Washington.

One day, Chihuly has the good fortune to meet architect **Robert Landsman**, who is hitchhiking toward Jericho, Jordan. Together, they visit the extraordinary site of ancient Petra, whose major monuments are carved from rock. Not only does the visit arouse in Chihuly a love of stone surfaces, but it fuels his passion for creating art on a monumental scale. A revitalized Chihuly heads home in 1963 to the University of Washington. In an assignment for his weaving class, Chihuly is required to make use of a "nonfiber" material in a weaving, and this proves to be the occasion of his first serious glass artwork, *Glass Weaving*, in which glass shards are interlaced with metal wires that he has fused into the glass. Smitten with his new art form, Chihuly is awarded the Seattle Weavers Guild Award in 1964 for his innovative use of glass and fiber.

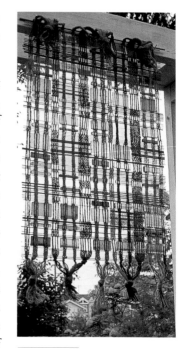

Glass Weaving. 1963

A Train trip in 1964

Chihuly takes a train trip across Canada in 1964 and carries with him a tube of each Winsor Newton water-

color. His only activity throughout the six-day trip is to mix colors and paint them on swatches, which he then organizes in albums used to hold stamps.

Sound Byte:

"So, on the train, I made all these colors. Of course, in six days I could only make a few thousand colors and that didn't even approach all the situations possible. Until you do that, until you start mixing all those colors, you don't know what colors can do."

—DALE CHIHULY, 1992

Dale with his mother. 1965

All the elements of the prototypal Chihuly artwork can be found in this story: the joy of "exploration" combined with the inspiration he derives from taking adventurous trips; his obsession with materials and series; and his willingness to indulge in what others might perceive as repetitive work, but which he enjoys for the sake of the process.

Studio in a basement

In 1965, Chihuly receives a B.A. degree in interior design from the University of Washington and goes to work for John Graham Architects in Seattle, designers

of Seattle's towering Space Needle, a landmark of the 1962 World's Fair. There, he assists with the firm's design of shopping malls. During this time, he meets the renowned textile designer **Jack Lenor Larsen**, who becomes a mentor and friend. Experimenting on his own in his basement studio, Chihuly blows his first glass bubble, using colored flat glass and a metal pipe. From this moment on, Chihuly knows that he wants to be a glassblower.

Sound Byte:
"That little basement only had a six-foot ceiling, and one night I melted stained glass between four bricks in a little ceramic kiln. I put a pipe in there and rolled it up and took it out and blew a bubble. And I had never seen glassblowing done. As soon as I blew that bubble, I wanted to become a glassblower."

—DALE CHIHULY, 1996

The new Tiffany

Many observers compare Chihuly to Louis Comfort Tiffany, the American maestro and impresario of art glass who gave the world fabulous gemlike lamps and monumental windows of extraordinary handmade glass. Chihuly is a worthy successor to Tiffany. Like Tiffany, Chihuly works with glass as his primary material, exploring a wide variety of styles and adapting them to his own sensibilities. Also

like Tiffany, Chihuly employs a huge staff of makers, installers, and advisers, without whom he could not carry out his agenda. One finds Tiffany windows in more than 1,000 churches, in addition to the thousands of lamps and countless blown vessels by the artist. Chihuly's work can be found in more than 175 museum collections and in numerous traveling exhibitions throughout the world.

Any direct American link with Tiffany was broken, however, in the years just before and after World War II. At that time, Tiffany's work fell out of favor, his factory was closed, and glassmaking became primarily the domain of industrial designers. Before Chihuly could take glass to new levels of creativity, art glass needed a revival. This came in the form of *studio glass*, à la Harvey Littleton.

Harvey Littleton to the rescue

By 1966, Chihuly is obsessed with the idea of becoming a glassblower, but how to do this? At the time, there is no place to study glassblowing in the Northwest. But he learns that the artist **Harvey Littleton** (b. 1922), founder of the *studio glass* movement (description to follow), has recently begun to teach glassmaking in the art department at the University of Wisconsin–Madison. It is the first glass program in the United States—an innovation at a time when most of the world still thinks of glass not as art, but as something functional that one gives as a wedding gift. Born in Corning, New York, Littleton is the son of one

of the inventors of Pyrex™ glass. During World War II, he had sought to reinvent the lost traditions of *art glass* by moving glassmaking out of the factory and into artists' studios—hence, the term *studio glass*.

Out to sea

Lacking the money to continue his education, Chihuly convinces a friend to get him a job on his father's fishing boat in Alaska, while in turn offering to find his friend a job at John Graham Architects.

The scheme works: Chihuly goes fishing and makes money at sea, where he finds great happiness. (Recall: His childhood walks along the shore and his ongoing love of the water will play a major role in his creation of *Seaforms* and in his decision to locate his facility on a lake in Seattle.)

Dale attends the University of Wisconsin–Madison in the fall of 1966 on a full scholarship. Madison offers him the chance to hang out with others his own age who have serious ambitions for careers as artists. From the start, Chihuly approaches glass as a sculptural material and not merely as an ornamental art form.

His courses give him the chance to bring together the transparent forms of glass and neon inside Plexiglas containers. In 1967, he receives an M.S. degree in sculpture.

THE ABC's OF GLASSBLOWING

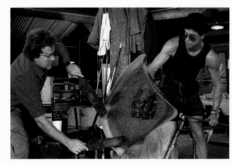

TOP
Reheating a *Venetian* in a glory hole. 1991

BOTTOM
Dale shapes the rim of a vessel as William Morris spins it. Pilchuck hotshop. 1983

Origins of glassblowing: Contemporary glassblowing is built on ancient techniques and traditional forms, and much of its vitality comes from adapting these processes and shapes to contemporary ends. As late as the 1960s, a few glass factories were still operating with wood-fired furnaces laboriously stoked by apprentice glassmakers who had to keep the temperature exactly right or risk ruining the glass and filling the **blowing room** with acrid smoke. Although oil and gas and even electric furnaces have replaced the wood-fired ones, the basic steps in glassworking have remained essentially unchanged since the time of the Roman Empire, when glass-blowing was invented.

The Hotshop: Glassblowing is done in a **hot-shop**. The furnace contains molten glass held at about 2150 degrees Fahrenheit. The round, gas-fed heating chambers are called **glory holes**. Computer-controlled **annealing ovens** (see below) allow finished pieces to cool at a controlled temperature over a period of time to reduce tension within the glass.

The Team: Unlike other forms of art, such as painting or sculpture, hot glass requires teamwork. The person in charge of the piece

being created is called the **gaffer** (or **maestro**). He or she is the team leader and has one or more assistants who blow the glass at the bench while the gaffer shapes the piece; they also shield the gaffer's arm and hand from the hot glass and bring bits of glass and **punties** (defined below), prepare colors, and generally help out as needed.

Tools: The glassblower's tools have remained virtually unchanged for hundreds of years. Most tools are made of steel or wood. Glassblowing tools are expensive; a basic set, including a **blowpipe**, costs about $500.

Temperature: Glassblowing requires a dance between extremes of temperature. If the glass is too hot, it will flow like honey and lose its shape. If the glass cools down too much, it will become too hard to blow and may crack off the pipe and shatter on the floor. The gaffer must maintain an even temperature by constantly reheating the glass in the glory hole (or by using hand-held blowtorches), and by stopping the heating process before the glass becomes too "floppy." Gaffers use compressed air to cool down key areas of the pieces being worked on; they use blowtorches to heat other areas up.

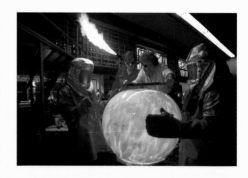

TOP
A molten *Float* ready to go into the annealer. The Boathouse. 1991

BOTTOM
Dale with a blowpipe in the RISD hotshop. 1977

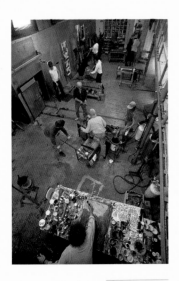

Team blowing at the Boathouse with Chihuly drawing at the bottom. 1991

Here's how it works:

(1) Mixing the ingredients: The raw materials for glass are **silica** (i.e., sand or quartz) and **flux ingredients** that make it easier to melt the silica by lowering the melting point of the sand. (These ingredients also make the glass more resistant to decay, and they provide color and texture.) This mixture, called a **batch**, is shoveled into a furnace where it can be melted into a liquid.

(2) Gathering the glass: The **molten glass** (i.e., glass that is hot and melted) is extracted from the furnace on the end of a carefully machined, hollow piece of steel pipe called a **blowpipe**, the basic glassblowing tool. This produces the first **gathering** of glass. If you've ever removed honey from a jar with a wooden stick, you're familiar with this process. The blowpipe is continually rotated to keep the gather of glass centered, as with a glob of honey. It is possible at this or at later stages to add **color** to the glass (see next spread).

(3) Blowing bubbles: The first gather of hot glass is rolled on a steel table called a **marver**. A large bullet-shaped solid mass is created at this stage, thereby forming the beginning of the glass vessel. The glassblower breathes air into the blowpipe and a small bubble emerges at the other end, within the mass of molten glass. After the gather has cooled, additional layers of glass can be built up around the initial gather. Wooden paddles are used to flatten the end of the bubble, creating what will become the **foot**, or flat bottom, of the piece. Ladlelike **blocks** are used to shape a bubble into the desired shape (e.g., oval,

round, elongated, etc.). This stepwise process enables the artist to coax the shapeless mass into an infinity of forms and sizes.

(4) Modifying by reheating: To prevent the vase from breaking apart, the gaffer will often hand his blowpipe to an assistant, who takes it to the *glory hole* for reheating. There, the rapidly cooling glass is softened by a blasting flame and made ready for reworking. The shape, exceedingly hot from the glory hole and rapidly slumping under the weight of gravity, can be adjusted by a skilled team. Any problems can be repaired at this time.

(5) Newspaper: Because the molten glass is too hot to touch, the gaffer sometimes presses folded, water-soaked newspapers against the gather as it is rotated at the bench in order to smooth and shape the bubble. Water keeps the newspapers from catching fire but creates a lot of smoke, which adds to the drama of the process. As the paper burns, it creates a layer of carbon, which acts as a lubricant and keeps the glass clean.

(6) The punty: Once the basic shape of a piece is established on the blow-pipe, it is time to open up the mouth of the vessel. Steel or wooden tongs called *jacks* are used to disconnect the neck of a piece from the blowpipe and transfer it to a *punty* (from the Italian word *pontil*), also called a *pontil rod*. Unlike the blowpipe, which is hollow, the punty can be either solid steel or a closed-off hollow tube, and is used to hold the hot glass during the final stages of glassblowing. It is fused to the end of the gather, at the foot of the piece, opposite the end to which the blowpipe had been fastened. **Scissors** or **shears** can be used to cut the molten glass, trim the lip or mouth of the vessel, and form the rim. Jacks are used to open the vessel. If the vessel requires a handle, a foot, or some three-dimensional decoration, a studio assistant can bring a specially shaped solid **bit** of hot glass to the gaffer at the bench, where it is fused to the object being made and cut off with scissors. The **open neck** of the piece, where it had once been attached to the pipe, becomes the neck of the glass vase or the mouth of the bowl. Paddles and

jacks are used to finish the mouths of vases and bowls once the piece is on the punty.

(7) Relieving stress points: When the process is judged complete, the finished vessel is cracked off from its punty and goes into the ***annealer***. The annealer is an oven where, over a period of hours or days, high heat is slowly decreased to room temperature, and where the stresses that have built up in the glass from all the reworking are diminished. If the glass cools too rapidly, it will break or explode from the unrelieved stresses. It is not uncommon for glass to fracture in the annealer, despite these precautions.

(8) Polishing: Afterward, the glass may be cold-worked with special polishing equipment. For example, the removal of the punty leaves a scar on the base of the vessel and this is often polished away.

Adding color: Color can be added at many stages. In some factories, there are special pots in which different colors are melted, and the first gather can be of red, or blue, or white, etc. In studio glass, for reasons of economy, the furnace usually melts clear glass only. Most artists start out with a bubble of clear glass, then add color as they "build" their piece. Color for glass comes in three forms: **(a) Color rods**, which are literally long rods or bars of concentrated colored glass. To create a colored vase or bowl, the gaffer will break off a 2" to 3" chunk of color rod, heat it up in a small kiln known as a ***hot box***, and pick it up on the ***punty***. The blob of color is "dropped" and spread to cover a small bubble of clear glass on a blow-

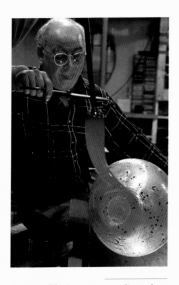

Lino Tagliapietra applies a hot bit of glass to a *Venetian*. 1991

pipe. More clear glass is layered over the colored bubble, and, when the bubble is "blown out," the color tints the entire piece. Once bars have been softened, they can then be applied as threads to the glass. It is possible to encase this in a second layer of clear glass, then add more color, and so on. That is what gives extraordinary depth to the object. **(b) Frits**, which are coarsely ground "crumbs" of color. A gaffer will dip a hot glass bubble into a pile of frits just as you would dip an ice-cream cone into jimmies, or he will roll the molten gather on the marver table into some frits that have been spread out on it. Frits add color in a speckle pattern, as in the Chihuly *Macchia* vessels. **(c) Powder**, which allows for fine gradations and layers of colors. Powder is sifted over the hot glass bubble. Color is made by infusing chemicals, some containing metals, into the glass; the powders contain the metals (copper for green, cobalt for blue, gold for a ruby color).

Thus, colored glass can be very expensive. A single color rod costs between $15 and $60, depending on the color. Because different metals heat and cool at different rates, not all colors are compatible. This means that even after a piece is blown and annealed, if incompatible colors are used, the glass may break apart on its own after it is taken out of the annealer.

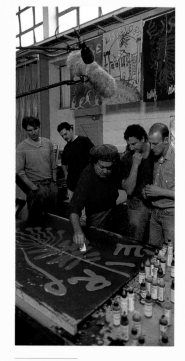

Dale applying color to a piece of paper as he creates a drawing at Waterford Crystal. Waterford Ireland. 1995

Fab times at RISD

After graduating from UW–Madison in 1967, Chihuly enrolls at the prestigious Rhode Island School of Design (RISD) in Providence, a college without a glass program but known for its world-famous talent. For a time, Chihuly occupies the house where Edgar Allan Poe had once lived, and establishes his studio in the basement of a converted funeral home. There, he continues his exploration of environmental works using flashing and crackling neon, argon (an inert gas like neon that also illuminates when an electrical current passes through it), and blown glass. Sometimes he hangs the forms from the ceiling, like "slabs of meat from a butcher," blowing and pouring molten glass from atop a ladder. He experiments with the pull of gravity on materials and seeks to create temporary artworks for theatrical effect outside a commercial context.

Bienvenu au Canada!

In the summer of 1967, during a visit to EXPO67, the World's Fair in Montreal, Chihuly is inspired by the large-scale architectural glass works of **Stanislav Libensky** (b. 1921) and his wife, **Jaroslava Brychtova** (b. 1924), in the Czechoslovakian pavilion. Back at RISD, Chihuly becomes friends with the Italian sculptor **Italo Scanga**, (b. 1932), who is then teaching at Penn State University but lecturing at RISD. The two artists share an interest in art, food, and antiquing, and, to this day, consider themselves brothers.

The Venice connection

In the fall of 1968, Chihuly receives a Fulbright Fellowship for study abroad at the prestigious Venini glass factory in Italy. (He is the second American to do so.) He sets out for New York, where he boards the *S.S. Michelangelo*, headed for Venice and the island of Murano, situated in the Venetian lagoon—an important glassmaking center since the Renaissance. The Venini glass house and factory on Murano is legendary for its elegant, modern designs that avoid the fussy, flamboyant shapes and colors of Venetian tourist-trade souvenir glassware.

Intro to Installations

Despite the legendary secrecy of the Murano glass factories, where the tricks of the trade are protected fiercely, Chihuly receives a choice project from the director of Venini, **Ludovico de Santillana**, who is also the son-in-law of its founder, **Paolo Venini** (1895–1959). Impressed by Chihuly's energy and budding talents, Santillana gives the young artist an opportunity to make a model for a proposed **sculptural installation** for the city of Ferrara. It is Chihuly's first exposure to a form of high-profile "installation" for which he will become famous in later years.

The Idea of Teamwork

Dale at Venini. 1968

While at Venini, Chihuly does not actually end up making any glass, but he observes masters blowing glass in concert with teams of assistants, a working style he will later adopt and refine.

After returning to the United States, he receives the M.F.A. degree in sculpture in 1968 from RISD and is awarded a Louis Comfort Tiffany Foundation Grant for work in glass. A visit to tiny Block Island, off the Rhode Island coast, marks the beginning of his love for islands and isolated spots. Block Island becomes a favorite retreat during his years on the East Coast. From that point on, Chihuly frequently seeks out islands and proximity to the water as a means of self-renewal.

Über-Teacher

By the autumn of 1969, Chihuly is back in Providence and establishes the Glass Department at RISD, where he will teach for the next 15 years. Anyone who has seen the obsessive, self-confident, and highly observant Chihuly in his "teacher" or "mentor" mode knows that he is enormously demanding but also hugely supportive.

Sound Byte:

"I like to be completely involved with whatever I'm doing. If you had me sweep the floor, I would do a better job than anybody else. If I was trying to decide whether to hire someone and asked him to sweep the floor, I could probably learn more from that than any other part of the interview. Think about it: In a hotshop, you can't make too much dust. You can't move too fast. Can't push the dirt in the wrong direction. A lot of decisions to make; you have to watch what you're doing."

—DALE CHIHULY, 1995

Protesting the War

On April 26, 1970, President Richard Nixon approves an invasion of Cambodia by American forces to attack North Vietnamese Communist bases established there. Eight days later, members of the National Guard fatally wound students at Kent State University in Ohio who are protesting the offensive. When the administration at RISD decides to shut down the school because of student protests over this "Cambodian offensive," Chihuly and a graduate student, sculptor **John Landon** (b. 1946), construct a 16 x 24' billboard as a protest against Nixon. Chihuly applies union-organizing abilities learned from his father to pull together a group of supporters who

Dale Chihuly. 1970

help build the 1,000-pound structure. In a way, this is his first realized installation project.

Exploring nature

Eager to move beyond the restraints of academic training, Chihuly, Landon, and others begin formulating ideas for the creation of a small alternative school where students can live and work in a natural, hands-on setting. They are inspired by such existing innovative learning environments as the Haystack Mountain School of Crafts in Maine and the Penland School of Crafts in the mountains of North Carolina. Because the climate of the Northwest is ideal for glassblowing (i.e., it is neither too hot nor too cold), Chihuly returns home to Washington State and begins hunting for a location in the spring of 1971.

Pilchuck is born

Chihuly finds a location for his school on a 16,000-acre tree farm about 50 miles north of Seattle, and he arranges to have **James Carpenter**—an illustration major at RISD with whom Chihuly had begun a four-year artistic collaboration in 1970—drive his van, full of furnace materials, cross-country for a rendezvous on the West Coast.

In June 1971, Chihuly and about 18 students establish the Pilchuck Glass School on land donated by Seattle art patrons **Anne Gould Hauberg** and **John Hauberg**. John Landon constructs a Sioux-style

John Hauberg
at Pilchuck
1982

ABOVE
Dale's cabin
Pilchuck Glass School

LEFT
Pilchuck Glass School
Stanwood, Washington
1983

tipi as the artists' first dwelling. It rains nearly every day that summer and Chihuly focuses on getting the hotshop running as soon as possible. Within 14 days, the group opens what the artist affectionately calls "a little facility to blow glass." The glowing furnaces provide spiritual and physical comfort in the midst of all the muck and drizzle, while the students cook food over campfires in the rain and wash with muddy water from a nearby spring. By merging hot glass and water, and by using large bubbles of clear glass blown at the furnace, Chihuly completes his first environmental installation at Pilchuck—a series of invisible but shiny, thin-walled but unsinkable pods that he floats in the pond near the school. The piece later becomes known as *Pilchuck Pond*.

33

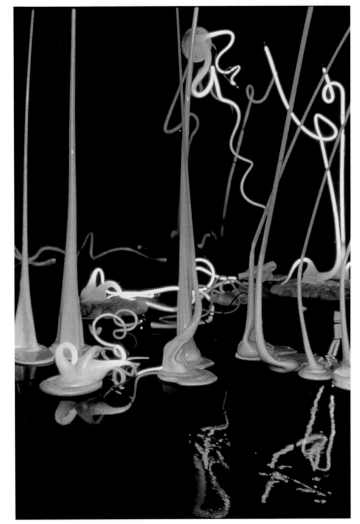

Glass Forest #1
1971–72
Glass, neon
and argon
American Craft
Museum
New York
New York

Fire and ice

Chihuly resumes teaching at RISD in the autumn of 1971 and, with Carpenter, creates and installs the breathtaking *Glass Forest #1* in 500 square feet of space at the American Craft Museum in New York City. Carpenter's interest in botany and architecture enriches the collaboration process, which he describes as an inquiry into luminosity, reflection, and transparency. At the museum, tall and slender glass tendrils share space with illuminated mercury and argon tubing. The resulting environment of this erotic installation is a dramatic, strangely surreal forest that reaches six to nine feet high and in which the bases of the tendrils resemble a stream of milky-white fluid flattened as they plunge into the ground.

Razzle-dazzle of neon

Later that fall, Chihuly and Carpenter become interested in an old ice-house located near their neon supplier, and they begin an exploration of neon and ice. The result—known as *20,000 Pounds of Neon and Ice*—is the high point of their collaboration. They freeze U-shaped neon tubes into molds filled with water, which produce roughly 60 blocks of glowing ice that weigh 300 pounds each. It takes about ten days for the ice to melt fully, and as the ice turns to water, the tubing is released and the regular geometry of the neon falls into disarray. The icy light from within the solid blocks is transformed into a watery light as it reflects from the puddles.

Sound Byte:

"Chihuly and Carpenter brought together primal elements—fire and ice—in a hi-tech way, in effect raising the question of Robert Frost's poem: 'How will the world end? Will it freeze in ice or sizzle like neon?'"

—DONALD KUSPIT, art critic, 1997

The collaborative work with Carpenter enters its final stages in 1973 at Pilchuck when they create *Rondel Door* and *Cast Glass Door*, compositions of blown glass and cast-and-mosaic glass—part sculpture, part craft object. The four blown-glass discs in the *Rondel Door* display the swirls of color that art critic Donald Kuspit calls the **vertigo principle** in Chihuly's work: rhythmic arrangements of color and form that evoke a kind of "delicious, dreamy dizziness."

In December 1974 at RISD, Chihuly completes his last project with Carpenter, *Corning Wall*, installed at The Corning Museum of Glass in upstate New York. These final collaborations are a kind of farewell to the motif of the temporary and the conceptual, and represent the beginning of a period in Chihuly's career when he focuses on making discrete, permanent artworks.

Sound Byte:

"I cannot understand it when people say they don't like a particular color. How on earth can you not like a color?"

—DALE CHIHULY, 1996

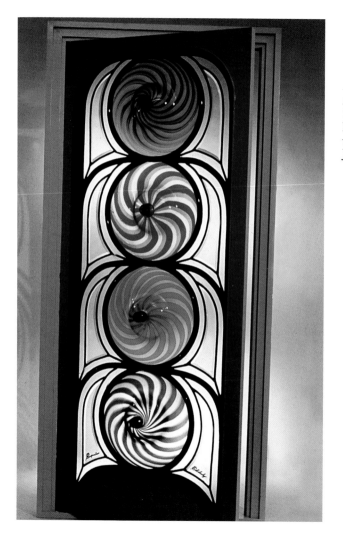

Rondel Door
1973
In collaboration
with
James Carpenter

A Taste of honey

Chihuly makes a trip to Europe in 1974 to visit museums and glass centers with **Thomas Buechner** (b. 1926), director of The Corning Museum of Glass. The charismatic Buechner has the ability and means to travel in style, and this leaves a strong impression on Chihuly, who is struck by Buechner's use of a helicopter at one stop in Germany to save time and to crowd more into their busy schedule.

Red-hot "drawings": the *Cylinders*

Chihuly returns to the theme of his earliest glass weavings when, funded by a National Endowment for the Arts (NEA) grant for research at Pilchuck, he joins Kate Elliott in developing a technique for creating glass "drawings" that consist of glass threads laid out on the marver, or solid metal-topped table. (Note: The word *drawings*, as used here, does not mean "illustrations," but rather glass strips that are pulled, or *drawn*, as one might pull taffy.) A cylindrical gather of glass is pressed onto the composition, and the two parts are immediately fused together. The molten glass bubble—sagging under its own weight but controlled by the glassblower, who rotates the blow pipe—acts as a magnet, defying gravity as it lifts the composition off the surface.

Since the resulting piece appears "functional"—i.e., it is a hollow cylinder that could also be used as a flower vase—the invention is dismissed by the art world as being "craft" or "decorative art."

By 1975, Chihuly has enough control over his technique to begin a series entitled *Navajo Blanket Cylinders*. Michael W. Monroe, curator at the Renwick Gallery at the Smithsonian in Washington, D.C., notes that the images on the cylinders look like a *second skin* on the surface of the thickly walled cylinder, much as a fiber blanket becomes a *second skin* for the Navajo wearing it. The drawings are created by thin threads of glass that are woven to resemble Navajo blankets and pressed onto the molten glass. A decade later, when Chihuly revisits this series with the vibrantly dramatic *Pilchuck Soft Cylinders*, he alters the embedded

*Artpark
Installation*
1975
In collaboration
with
Seaver Leslie
Lewiston
New York

39

drawings so that they become expressive abstractions distorted by manipulation of the bubble while it is hot. Chihuly later comments that he had been intrigued by the element of chance and mystery brought to the composition by the distortion that results from the pick-up process. The magic in these pieces lies in the drawing that is fused into each one of them.

Over the years, **Flora Mace, Joey Kirkpatrick, Kate Elliott,** and **Seaver Leslie** all assist or collaborate with Chihuly on the drawings for the *Cylinders*.

Hello, James Joyce

In 1975, the *Cylinders* further evolve into the *Irish* and *Ulysses* series. Inspired by James Joyce's masterpiece *Ulysses*—which focuses on a day in the life of the novel's three main characters—Chihuly creates a group of artworks that depict scenes from the book.

If medieval stained-glass windows were meant to provide a simplified guidebook for the faithful, then the multiple *Ulysses Cylinders* represent the hours in a day, each one expressing a different scene from the novel.

ABOVE
J. Capps & Sons *Blanket*
c. 1912

OPPOSITE
Peach Blow Cylinders. 1995

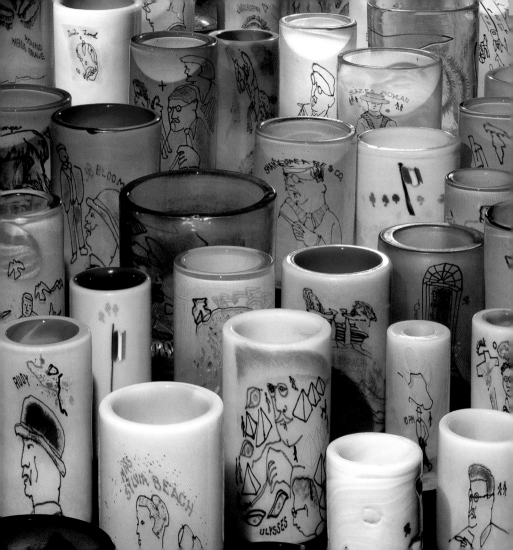

Tragedy strikes

Excited about his *Ulysses* series and eager to find an exhibition venue, Chihuly goes on a lecture tour of the U.K. to talk about the new work. Tragedy strikes, however, when he and a friend suffer a horrific car crash in England: Chihuly is thrown into the windshield and spends weeks in the hospital. He receives 256 stitches on his face and loses the sight in his left eye. His right foot and ankle are permanently disabled. Upon his return to Providence, Chihuly—now wearing a black eye patch—is asked to chair the sculpture department at RISD.

The loss of depth perception makes it difficult for the artist to blow glass and leads him to create a team of glassblowing assistants like those he had witnessed in Venice and at other European factories. He orders custom-made shoes to alleviate foot pain and paints them in order to conceal their awkward shape. The black eye patch soon becomes his trademark, like that of the Hathaway man in the shirt ads.

A Champion arrives

Perhaps fate sought to balance the tragedy of the car accident, for in 1976 Henry Geldzahler acquires three

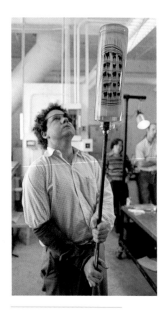

ABOVE
Dale blowing a *Cylinder* at RISD. 1976

OPPOSITE
Irish Cylinders
1975
In collaboration with
Seaver Leslie and
Flora Mace

Navajo Blanket Cylinders for the permanent collection of The Metropolitan Museum of Art. This recognition by a major museum represents a turning point in the artist's career, and a friendship develops between the two men.

Sound Byte:
"Chihuly challenges taste by not being concerned with it. His sole concerns are color, drawing, and form. He does go over the top at times, with pieces about which people say, 'This is really too much,' but perhaps not. Five or ten years later, it's no longer too much."

—HENRY GELDZAHLER, curator,
The Metropolitan Museum of Art, New York

Indian Summer

In 1977, Chihuly visits the Washington Historical Society in Tacoma, which houses a collection of Northwest Coast Indian baskets. Drawn to the gracefully slumped and sagging forms of these baskets, he decides to reproduce them in glass, and that becomes his mission for the summer.

He starts the new *Basket* series at Pilchuck with a group of small, delicate, and shiny baskets, colored with earthy tones and bound with simple wraps of dark-glass threads. As the *Baskets* evolve, Chihuly begins to nest them one inside another and to arrange them into groups so as to increase the scale.

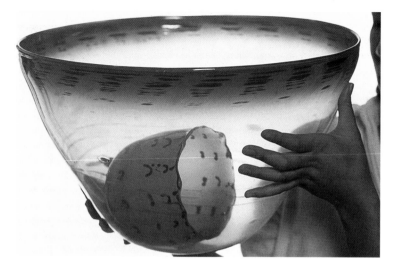

Basket Pair
1978
16 x 18 x 18"

A Major young Talent

The summer of 1978 marks the start of an eight-year working relationship between Chihuly and **William Morris**, a gifted student at Pilchuck, with Chihuly directing Morris as head gaffer. Chihuly's work is by now receiving wider attention in the museum world. Michael W. Monroe, of the Smithsonian's Renwick Gallery, organizes an exhibition called "Baskets and Cylinders: Recent Glass by Dale Chihuly." The show proves to be a milestone in Chihuly's career—so much so that, in 1979, The Corning Museum of Glass decides to

include his work in the exhibition "New Glass." The show travels to The Metropolitan Museum of Art, the Musée des Arts Décoratifs at the Louvre in Paris, and the Victoria and Albert Museum in London. It is the first time that large audiences are exposed to the new work, and the result is that collectors begin to take a greater interest in studio glass. Specialized galleries begin to open and it is clear that the groundwork has been laid for a thriving marketplace that will eventually allow Chihuly and other glass artists to work as independent artists.

Sound Byte:
"As I'm swimming in my lap pool, I think of things. And I try to put them in order in my mind...like if I think about lighting, I'll see some sand in the glass, and I'm thinking where in the hell is this sand coming from in this indoor swimming pool? So I'll say to myself, 'L, S, Lighting, Sand.' By the time I get out of the swimming pool, if I've been swimming for half an hour, I can remember a sequence of initials that will then trigger all my thoughts."

—DALE CHIHULY, 1998

Team Chihuly

During a 1979 trip to Southern California, Chihuly dislocates his shoulder while bodysurfing. This, coupled with the loss of sight in his

left eye, convinces him to hand over the role of gaffer to William Morris. Chihuly's role shifts to that of director of **Team Chihuly** and he begins to make drawings as a means of guiding the team toward the results he wants. His drawings evolve into works of art and will later accompany his traveling exhibitions.

Sound Byte:
"I am like a film director who deals with a lot of talented people: You pick your cinematographer, your sound person, etc. All these different people have specific tastes just as they do on the glassblowing team."
—DALE CHIHULY, 1992

A Chihuly team of glassmakers can vary in size from two people to a dozen or more. The team includes a back office of **business assistants** in Seattle, a **glassmaking team** (glassblowers, color experts, and technicians), **packers** and **shippers** (who know how to pack glass so that it won't break), a **mock-up and install team** (experts who construct the metal armatures used in lowering glass by cranes and for hanging *Chandeliers* in towering spaces; technicians in the plastics lab, architects, lighting designers, and builders), a **media team** (experts in photography, video, the Internet, and book publishing, such as those employed by Portland Press, which is owned by Chihuly), and **consultants** for everything from public relations to gallery sales.

Here's how they work

Since pacing and timing are important in working with molten glass, the gather must be kept at the correct temperature at each stage or it will result in defects (e.g., cracks) in the finished product. The team takes its cues by observing the head gaffer and anticipating his or her needs. As director, Chihuly plays an increasing role in challenging the team and in keeping its members fresh. For example, he takes the crew on a road trip in 1979 to blow glass in Baden, Austria, and creates work for an exhibition in Vienna. Factory-trained gaffers would no sooner think of leaving their familiar surroundings than a trained surgeon would consider leaving the hospital operating room, but Chihuly enjoys shaking up his team to keep the glassmakers on edge.

Working within a group brings other benefits, too, including a camaraderie that helps to energize Chihuly. The flavor of Chihulyan **performance art** permeates the blowing sessions, and this attracts a following of collectors, students, and visitors. In fact, a tour of the Chihuly Studio has become one of the hottest "unticketed" events in Seattle, even though the studio is not open to the public.

Anything goes

What's so great about watching a bunch of sweaty glassblowers? The excitement comes from the unscripted character of the work and the

high energy level of glassmaking: Anything can happen—and *fast*. Audiences are mesmerized by the **elements of danger**: There are the blasting hot furnaces and the scalding-hot glass that seems skewered on the ends of spear-shaped metal rods, with team members moving like gladiators as they struggle to control the process. From time to time, a fabulous piece that has taken hours to make implodes as it crashes to the ground.

Yet there are moments of comfort during this frantic process. The audience soon recognizes that the furnace around which it has gathered is like a campfire. The seeming chaos of the hotshop soon reveals a logic of its own as the team takes its cues from the gaffer and from Chihuly. Best of all, this alchemy and magic lead to the creation of magnificent works of art.

Seaforms

While experimenting with ribbed molds at Pilchuck during the summer of 1980, Chihuly transforms the *Baskets* into the *Seaform* series, in which:

- The **ribbing of the molds** adds strength to the blown-glass forms, just as corrugations and undulations strengthen everything from cardboard to seashells. This means that the **objects can be thinner** and appear diaphanous.

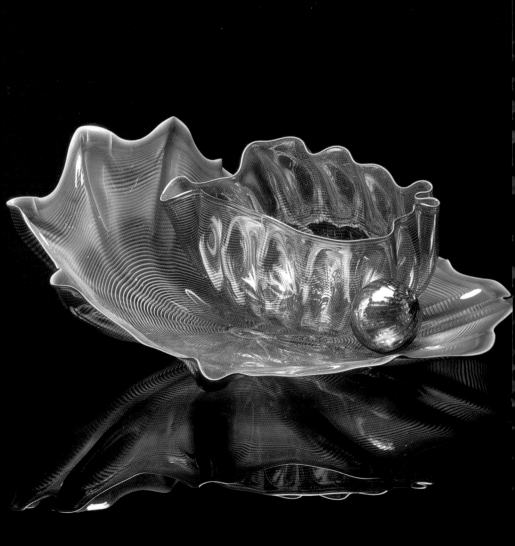

- **Thin glass threads** are trailed over the body of the softly contoured vessels.

- The **decoration and form of the vessel are fused together**, which creates elegantly abstract forms that **resemble sealife**. These incredibly delicate hollow shapes seem to the beholder to embody the jellyfish, anemones, ocean sprays, shells, and sea urchins that Chihuly remembers from his childhood walks along the beach as well as his later experiences on the water with poisonous Portuguese men-of-war and otherworldly underwater dangers.

- The pieces are shaped so that they will **nest intimately inside each other** (think of the fins and eyeballs of sea creatures).

- Exotic effects are captured with **thinly veiled colors,** sensuous as a dream.

Seaforms are extensions of Chihuly's explorations with color and form, part of the natural evolution he encourages by pushing his team to create ever thinner glass that is more under control. He integrates the "sea creatures" into the motif of *Seaform Pools,* a rich soup of glass, water, and light formed by an intricate tapestry of his sculptures set

ABOVE
Seaform Basket drawing
30 x 22". 1990

OPPOSITE
Seaform. 1984

RIGHT
*Verditer Blue
Seaform Set
with Yellow
Lip Wraps*
1989
14 x 26 x 25'

OPPOSITE
*Seaform
Lap Pool*
1998
12 x 54 x 4'
The Boathouse
Seattle
Washington

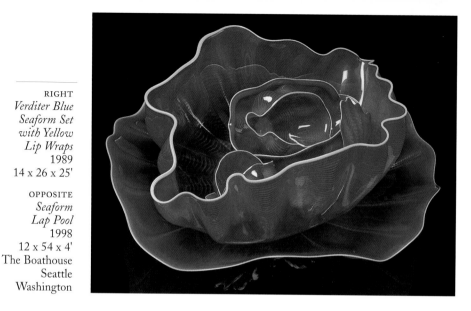

into a glassed-in niche on the bottom of a swimming pool. The *Seaform Lap Pool* at his Boathouse in Seattle is a great example of this. The shifting kaleidoscope of colors has the magical, jewel-like quality of a sunken treasure chest, open on the bottom of the sea. The *Seaform* pieces are sealed under safety glass, which protects both the artwork and swimmers from injury. Lighting is provided by waterproof technology.

Persian Ceilings are a variation on this theme. Here, the art rests on a glass ceiling suspended above a walkway or hallway. Light cascades

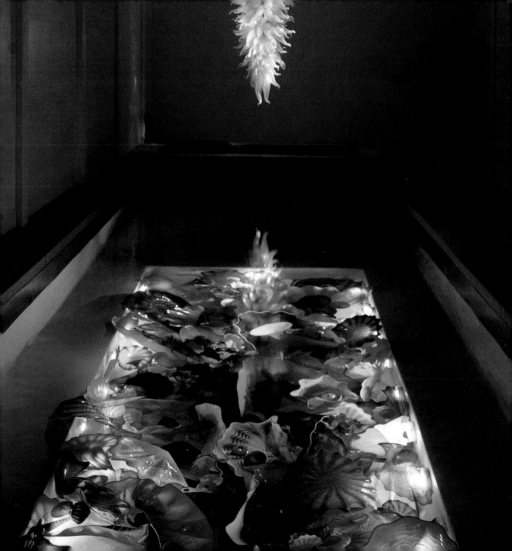

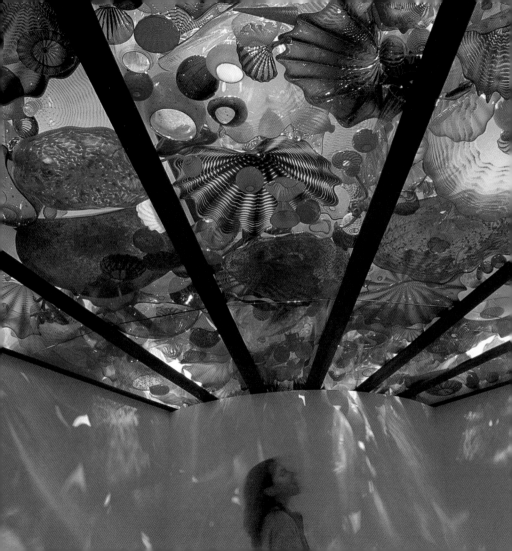

through the glass, casting soft, multicolored shadows on the walls and floor of the corridor. Viewers are enveloped in color as they pass beneath.

Sound Byte:
"Effortlessly I glide through a sapphire sea, admiring sparkles on the underside of slick, moving wavelets rimmed with light, gently cupping an ephemeral bit of living jelly in my hand, then turning to glimpse a dazzling sight: coral, sponges, anemones, in a riot of soft pinks, blazing reds, luminous oranges, all marked with the disciplined wildness that I love in nature— and in the Seaforms. *I am not underwater. Rather, I am looking at remarkable photographs of Chihuly's glass."*
—SYLVIA EARLE, chief scientist, National
Oceanic and Atmospheric Administration, 1995

The successful reception of his work by museums and collectors, combined with the increasing prominence of the Pilchuck School, enables him in 1980 to resign as head of the sculpture department at RISD and to focus on his work. He purchases his first studio building in Pawtuxet Cove, Rhode Island, and christens it the **Boathouse**.

OPPOSITE
Persian Ceiling
1998
Los Angeles
California

Macchias

In the summer of 1981, the *Seaforms* emerge from the ocean realm and evolve into the *Macchia* series. (*Macchia* is Italian for *spotted*.) One of

RIGHT
Macchia group
on lawn at
Pilchuck
c. 1986

OPPOSITE
*Aventurine
Green and
Yellow Macchia*
1981
6 x 9 x 9"

Chihuly's goals in creating the *Macchias* is to find a way to use all 300 colors available in the hotshop. Each bell-shaped *Macchia* has a brilliant, solid-colored interior that is separated from its riotously dappled outside by a layer of white-glass "clouds." The major innovations of the *Macchia* pieces are:

- **Dazzling colors:** Chihuly treats color as a three-dimensional transparent substance and as a material that he can fold and shape. Like the French colorist painter **Henri Matisse** (1869–1954), he knows the exhilarating effect that color has on people and fearlessly uses more combinations of colors in his *Macchia* pieces than in any of his other sculptures. He applies color so freely that it appears to

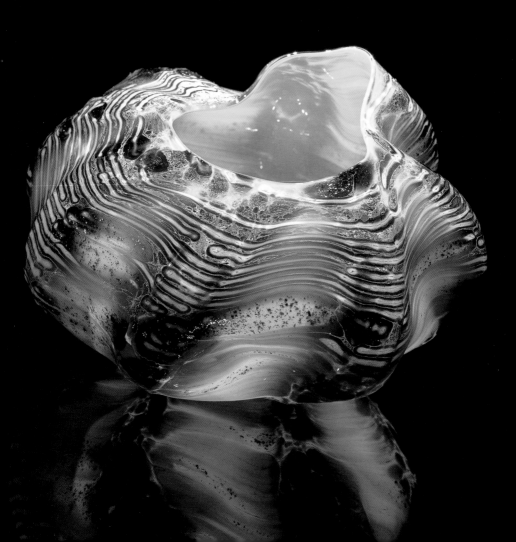

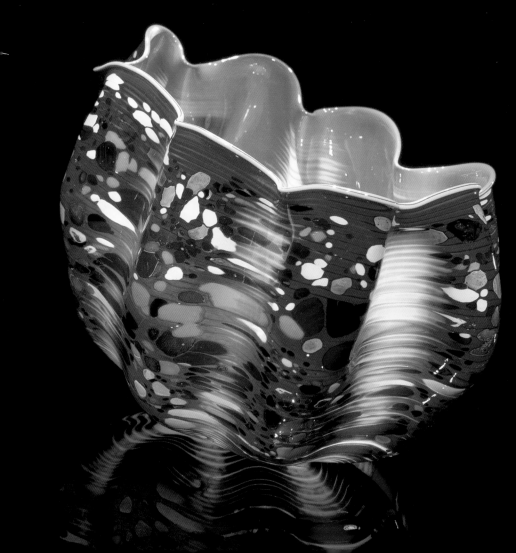

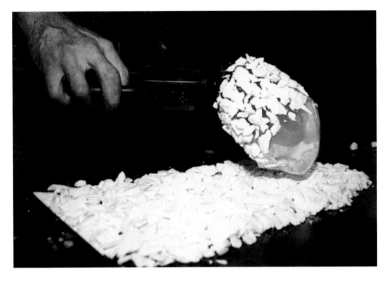

LEFT
Adding "clouds"
to *Macchia*
1983

OPPOSITE
*Cobalt Blue and
Chartreuse
Macchia*
1981
6 x 10 x 7"

move—in fact, it *does* move—three-dimensionally through the glass, creating a kind of vertigo in the viewer, a delightful confusion of color and structure that draws you into the work.

- **Choice of colors:** Chihuly chooses one color for the interior, one for the exterior, and a contrasting color for the lip wrap, while adding various jimmies and dusts of pigment between the various gathers. Colors are added layer upon layer throughout the blowing process.

- **White "clouds":** Chihuly discovers a way to put a white layer of glass—which he calls "clouds"—between the inner and outer colors.

It's the white that allows the colors to pop. It's like the white primer that painters use on their canvases: It helps to clarify and enhance the colors by making it possible to have color on the interior and color on the exterior without any blending of the colors.

OPPOSITE
Macchia Forest
1992
45 x 25 x 10'
Seattle Art
Museum

Macchia Forests

When presented in an installation, the *Macchia* pieces are often grouped into *Macchia Forests*, an unlimited number of wildly colored large glass forms on stands of varying heights. Perched upon these stands, the *Macchia* pieces take on the aspect of a mystical woodland of futuristic flower-trees. As an interactive installation, the *Macchia Forests* allow viewers to walk between the stands and come eye-to-eye with the blazing sculptures.

Displaying the *Macchias* at various heights highlights their different elements—the crush of inside color, the dizzying color spots on the outside, the strong but undulating lip wrap, and the sometimes translucent bottom. Standing back to look at the installation as a whole, you have the impression of experiencing every color in the spectrum all at once, with no color repeated and no color left out.

Sound Byte:
"My work revolves around a simple set of circumstances: fire, molten glass, human breath, spontaneity, centrifugal force, gravity."
—DALE CHIHULY, 1993

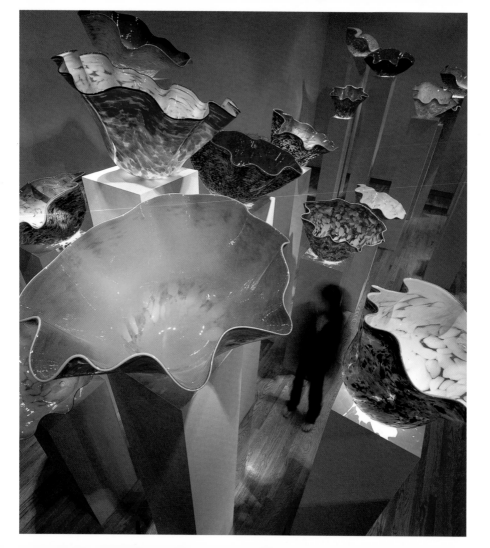

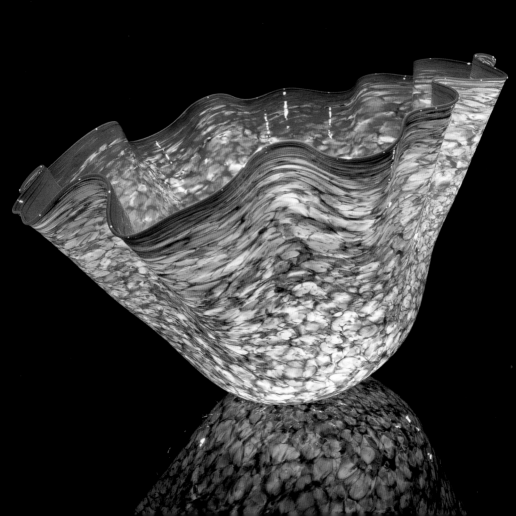

Chihulyland

Even though it may seem at the time a bold move to trade job security for the risks of self-employment, Chihuly's timing is perfect: It is the dawn of the great era of studio-glass collectors and Seattle is coming into its own as a "wonder town." In the spring of 1982, feeling his freedom, he cycles 1,000 miles throughout Brittany, France. In 1983, he sells his East Coast studio and takes off for the West Coast.

OPPOSITE
Rose Madder Macchia with Paris Blue Lip Wrap
1993
18 x 29 x 32"

Sound Byte:
"I was looking at all these color rods, these 300 different color rods that make up our palette for glassblowing. They come from Europe, mostly from Germany. And at that point, I had probably only used 10 or 20 percent of these colors. I woke up one morning in 1981 and said, 'I'm going to use all 300 colors in as many possible variations as I can.'"
—DALE CHIHULY, 1992

Chihuly's move to Seattle unleashes in him a tremendous burst of creativity. In 1984, he revisits the *Cylinder* series, softening and enlarging the forms. When not working, he travels to places hither and yon, receiving awards from RISD and the American Council for the Arts, in addition to being honored by three state Governor's Art Awards.

Dale yearns to find himself a place on the water, and by 1985 he is able

Pilchuck Cylinder (Navajo Blanket Series)
1984. 13 x 9"

to purchase the Buffalo Shoe Company Building, which overlooks—but does not touch—the waterfront of Lake Union. It is a "working lake" in Seattle lined with industrial buildings that serve the fishing and boating industries. Five years later, he gets lucky: An old boat-building warehouse is up for sale and Chihuly buys the 45,000-square-foot structure, also located on Lake Union. It is a dream come true for the artist and he promptly christens his facility the **Boathouse**.

The Seattle region is a maze of waterways and lakes and sounds, rich in nautical history. Chihuly's Boathouse, located near a narrowing passage on the lake, has a view of logging barges, tugboats, and pleasure yachts that zigzag beneath the windows. There, Chihuly creates **Chihuly Studio**—part artist's studio, part Batman cave, part control room, with soundproofing that dulls the noises from outside. Eventually it houses his hotshop, complete with a sound system for playing loud rock music in infinite loops, over and over again, like a mantra. Open a door and you might find a serene lap pool sheltering a secret reef of glass on the bottom of it, or maybe a drawing room (in the literal sense) with an 87-foot dining table cut from a single Douglas fir tree,

or a retro 1950s-style kitchen where hungry glass-blowers are served anything from risotto with peas to an entire smoked turkey (depending on the cooking skills of the visiting gaffer), or you might even find yourself in the office of Chihuly's business manager.

> **FYI: No noise, please!**—Whenever Chihuly is at work in the hotshop or listening to the dozens of daily messages in his voice-mailbox, he is annoyed if extraneous sounds interfere with his concentration. Whispers are intolerable when he is on the telephone. He plays loud music while in the studio in order to mask other noises. It's during these maximum modes that Chihuly accomplishes his most creative work, energizing those around him to push themselves to higher levels of creativity.

Installations and *Persians*

Anxious to push his art in new directions, Chihuly begins working on a grand scale in 1985. Within a year, he is already developing a new series, *Persians*, with a RISD student, **Martin Blank**, as gaffer. His signature installations are known as the *Persian Windows* or *Persian Walls*. These installations can incorporate anywhere from three to 25 or more large flowerlike glass forms that are mounted so gracefully on a window or wall that they appear to hover in midair, as in Tacoma's Union Station.

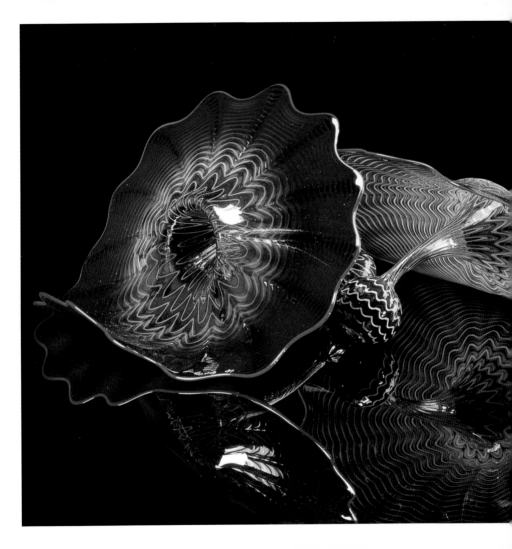

Here's what to look for in the *Persians*:

- Each colorful *Persian* looks like **liquid frozen in motion** and can span up to three feet in diameter.

- **Their gently fluted edges** and fine, spiraling body wraps give the illusion of motion.

- They are skewed into a **herringbone pattern** and call to mind the swirling of Arabian textiles.

The pieces are often arranged in a dramatic motion that sweeps across a plane. When creating a *Persian Window* or *Wall* installation, Chihuly often looks for wall or window spaces adjacent to stairs or elevators, so that the viewer can experience the sculpture from different heights.

With the opening of *Objets de Verre* (i.e., "Glass Objects") at the Musée des Arts Décoratifs at the Louvre Museum in Paris in 1986, Dale Chihuly becomes

Cobalt Persian Pair with Red Lip Wraps
1997
13 ¹/₂ x 33 x 25"

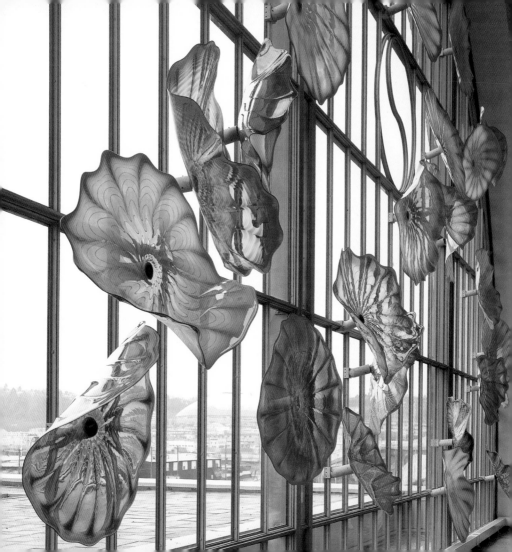

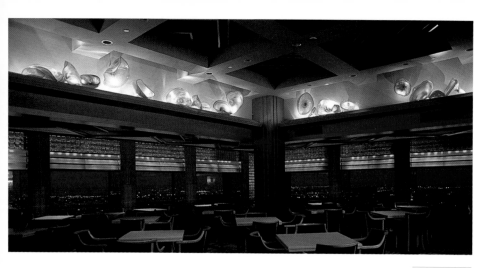

one of only four American artists to have a one-person exhibition at the Louvre. The same year, he receives honorary doctorates from the University of Puget Sound and from RISD.

New York, New York!

By now, Chihuly's work is well known internationally, and in 1987 Henry Geldzahler recommends him as the artist to create a permanent installation for the **Rainbow Room**, a posh dining room on the 65th floor of the G. E. Building at Rockefeller Center in New York City. His *Rainbow Room Frieze* is a spectacle of glass forms that appear to float above a shelf just below ceiling level while also suggesting the tones of a Manhattan sunset. The project marks the beginning of

ABOVE
Rainbow Room
Rockefeller
Center
New York
New York
1988

OPPOSITE
*Monarch
Window*
1994
Union Station
Tacoma
Washington

Chihuly's association with artist **Parks Anderson** (b. 1942), who will become an essential member of Team Chihuly. Anderson provides vital assistance to the artist in orchestrating his increasingly complex installations. His calm and steady demeanor offers a counterpoint to Chihuly's alternating cycles.

Inspiration in Venice

In 1987, Chihuly marries playwright **Sylvia Peto** and honeymoons with her in Venice during the winter of 1988. There, they visit a palazzo that houses an extraordinary private collection of Venetian glass from the era between the two world wars. Many of these Art Deco–era confections had been designed for the glasshouse Venini (recall that Chihuly had worked there in 1968) by Italian sculptor **Napoleone Martinuzzi** (1892–1977), noted for his whimsy, and by architect **Carlo Scarpa** (1906–1978), known for his inventive combinations of materials and techniques. These creations remain the chief glories of Venetian glass and, because of their extraordinary beauty, are quite rare. For every 10,000 souvenir figurines displayed in the windows of Murano tourist shops, there is maybe one Martinuzzi animal figure, made by a maestro gaffer with consummate skill and jealously guarded on the shelf of some savvy collector who appreciates its lifelike qualities.

The Merchant of *Venetians*

Chihuly is astonished by these wildly innovative and beautiful pieces from the 1920s and 1930s. Ever the savvy businessman, he knows that their rarity drives collectors to snap them up whenever they become available. He'd love to collect them, but knows they are too rare. How to do it? Eureka! He decides to pretend that he is back in the 1920s and that *he*—Dale Chihuly—is creating these priceless items himself!

The following summer, he invites the Italian maestro **Lino Tagliapietra** (b. 1934)—an old friend and one of the world's foremost glassblowers—to work with him in Seattle as a gaffer. Thus begins the *Venetian* series. The first day, they make several pieces in period style, but as the series progresses, Chihuly finds that his "mind won't stay in the 1920s," so he starts making more eccentric objects.

Drawing and sketching with unbounded energy, and working with teams of 12 to 15 glassmakers, Chihuly evolves an extraordinary group of objects, some so enveloped in handles and applied flowers and leaves that at one point Tagliapietra calls him "more Venetian

Gold over Cobalt Venetian. 1989
22 x 12 x 11"

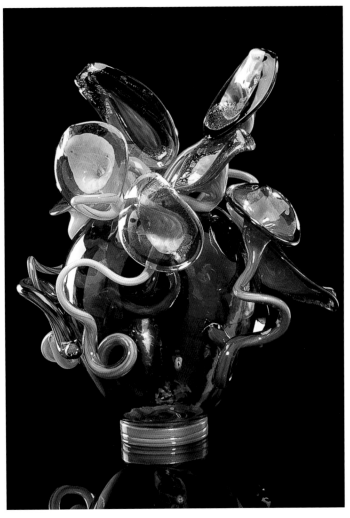

ABOVE
Venetian glass. c. 1925

RIGHT
*Transparent Green
Venetian*
1990
24 x 21 x 20"

than the Venetians." The flamboyant bits on the 1920s vessels were originally *handles*. (See opposite page, top left.) Chihuly takes them to their logical—well, maybe not logical—conclusion by stretching the glass to its breaking point and plastering it with wings.

The brassy colors seem to shout "We are over the top." And as if to make the point, in 1989, along with Lino Tagliapietra, Italian maestro **Pino Signoretto**, and a team of glassblowers at Pilchuck, Chihuly creates the *Venetian Putti* series. Signoretto creates the stocky angels with curly hair that are then applied to the vessels.

The result? A Chihuly *Venetian* has more acanthus leaves and serpentine coils than ever imagined by an original Venetian designer. Because the critics are so divided in their assessment of this work, the *Venetians* remains Chihuly's most controversial series.

Also in 1989, Chihuly begins the *Ikebana* series with Tagliapietra, inspired by a trip to Japan and his exposure to Japanese masters of flower arrangements. Some *Venetians*, such as the piece shown on this page, contain *Ikebana* stem components.

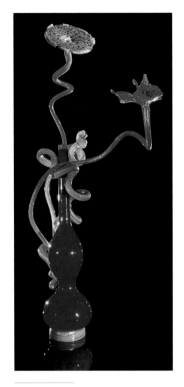

Ultramarine Blue Venetian with Two Red Stems
1991. 52 x 34 x 24"

The *Floats*

OPPOSITE
Niijima Floats
1992
Seattle Art
Museum

In 1991, Chihuly decides to push the envelope yet again by making the largest piece he can, hoping to create an object at least six feet tall. While a perfect sphere (i.e., a round ball) might seem to be the most natural shape for glassblowers, such a sphere rarely exists in glass, because as a shape it has little utilitarian function. Chihuly directs the gaffer to make a giant sphere with a "dimple," so that another sphere can be mated into it and flowers attached.

When these balls emerge from the annealer, Chihuly sees them as self-sufficient forms. Soon, his team is making some of the largest objects ever blown in glass. Chihuly colors, textures, and groups them into a series called the *Floats*. He uses this name because he recalls being fascinated by the buoyant, blue-green glass floats entangled in the Japanese fishing nets he encountered as he explored the seashore as a child. He is reminded of these childhood discoveries when he visits Niijima, Japan, in 1991. The *Floats* are Chihuly's most direct expression of the glassblowing process, since the sphere is the form most naturally created on the blowpipe. But at this scale—up to four feet in diameter and weighing 40 pounds or more each—they are the most technically challenging of all Chihuly's sculptures.

When the *Floats* are arranged as a group, especially in a natural setting such as a garden, they transcend their unassuming shapes and transmit an aura of mystery to their surroundings.

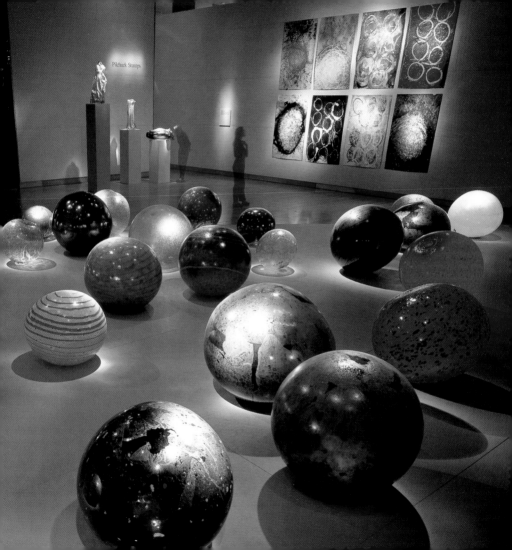

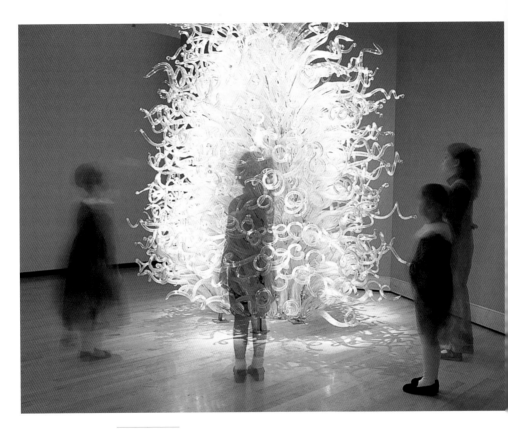

Palazzo Ducale Chandelier
1996. Kemper Museum of
Contemporary Art and Design
Kansas City, Missouri

Later that year, Chihuly also completes several large-scale architectural projects, one for GTE in Texas and one for a Shinto shrine in Japan. He and Sylvia Peto divorce in 1991.

Sound Byte:

"I was eating in a restaurant in Barcelona and the owner hadn't done much to the space except for putting two gorgeous chandeliers in it, which turned the club from a warehouse to a palace. I said, 'My God, what a concept for space—something that's hanging up there. It's glass. It's light.'"
—DALE CHIHULY, 1997

The *Chandeliers*

While working on the *Floats*, Chihuly is already moving in another direction—the *Chandeliers*, a series that will continue to evolve as he develops it. Chihuly knows that the 20th century had not produced many (if any) great chandeliers. His genius, in this case, is to realize that he can make a chandelier-sculpture without internal lighting and that this will free him from the traditional function that so compromises the form.

By 1992, he begins by hanging relatively simple blown components together to produce a simple hanging sculpture. He later starts to use

metal armatures and the sculptures become much more complex. Instead of creating arms that hold lightbulbs and conceal wires, he contrives arms that become **wildly interlocking sculptures**. A Chihuly *Chandelier* does not light up or turn on and off as a typical chandlier does. It can be lit from the inside with neon, or from the outside with halogen spotlights. It is a burning star in the spotlight, and in that sense it is always "on."

Aesthetically, the *Chandeliers* play the same role in Chihuly's work that stained glass had played for Tiffany: By expanding the scale of their work, both artists secure control over the immediate environment. Perhaps the most revolutionary aspect of the *Chandeliers* is that **they seem to mutate and multiply**: Before long, *Chandeliers* begin to appear on the walls, floors, and under the ground wherever he installs them. And what begins as a *Chandelier* in Sydney, Australia, might reappear a few weeks later on an ancient wall in Jerusalem, maybe with a few extra parts from a disassembled installation in Seattle added to the mix.

Show me the Numbers!

The *Chandeliers* launch Chihuly into a new era of exploration. His crew devises creative ways to track all the parts, to pack them efficiently and move them rapidly around the world in standardized shipping containers, then to construct and mount sturdy metal

armatures on site, attach the glass with stainless steel wires. The whole process is documented through use of the Internet, of course.

FYI: **Chihuly online**—Chihuly has one of the largest artist web sites on the Internet, at www.chihuly.com. Reports are filed "live" by the Chihuly media team from the sites of the artist's installations around the world. Founded in 1996, the web site received 2,500 hits a day by the year 2000. The same year, a search for "Dale Chihuly" on the Internet search service Altavista turned up 2,780 references to the artist.

A turning-point Exhibition

In 1992, the exhibition "Dale Chihuly: Installations 1964–1992" opens at the new Seattle Art Museum. This show marks a significant change in Chihuly's exposure to the public. It travels widely and attracts huge audiences.

Chihuly continually refines the show and, for the first time, replicates an earlier installation—*20,000 Pound of Ice*, from 1971—for the exhibition. A year later, he produces *100,000 Pounds of Ice and Neon* at the Tacoma Dome in Tacoma, Washington.

OVERLEAF
100,000 Pounds of Ice and Neon
1993
Tacoma Dome
Tacoma
Washington

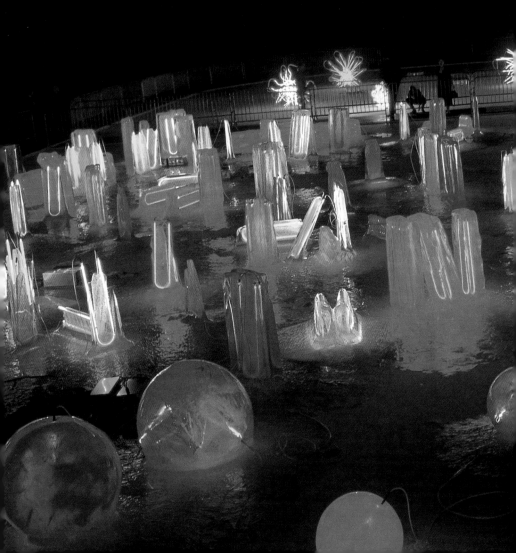

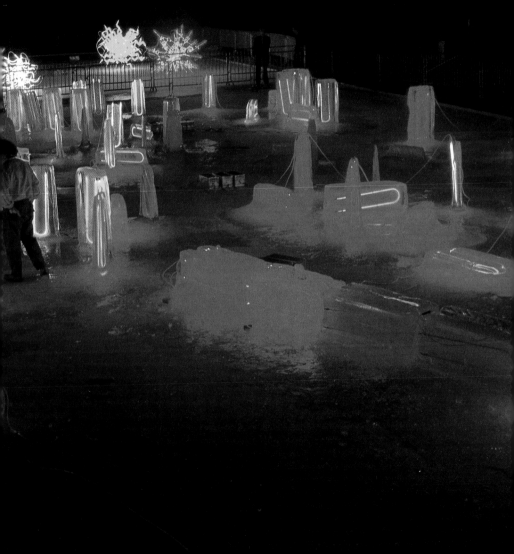

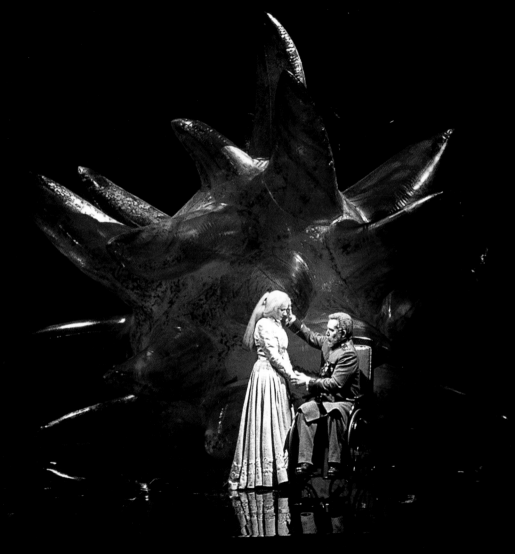

Never a dull Moment

Chihuly is invited to create stage sets for the Seattle Opera's 1992–93 production of Debussy's lilting opera *Pelléas et Mélisande*. In his first effort as a designer of theater sets, he produces glass models that segue into mirrored, shimmering sets, with synthetic materials that evoke a dreamy, fairyland atmosphere. Soaring tree trunks seem to be made of glass but are in fact plastic. The sets receive wide critical acclaim and represent Chihuly's return to environmental work.

From the Almighty Mouse...

Encouraged by the brilliance of the color that occurs when a piece is backlit, the artist begins a series of transparent paintings on Plexiglas. When Disney offers him the opportunity to create a ceiling sculpture for one of the company's new ocean liners, he realizes that plastic is the only choice, since fragile glass would not weather a storm at sea.

...to the Hilltop that roars

In February 1994, he begins dating **Leslie Jackson** (b. 1961), whom he had met two years earlier. A graduate student in Russian studies from the University of Washington master's program, Leslie soon plays a major role in Chihuly's life.

The same year, **Kathy Kaperick** (b. 1955), Chihuly, and long-time

OPPOSITE
Stage set
from *Pelléas et Mélisande*
Golaud's Room
Act IV, Scene 1
1993
Seattle Opera
Seattle
Washington

Chihuly with students at Hilltop program, Jason Lee Middle School Tacoma Washington

associate **Charlie Parriott** found the Hilltop Artists-in-Residence Program in the troubled Hilltop neighborhood of Chihuly's hometown of Tacoma, Washington. The program, which teaches at-risk teenagers to blow glass, has helped many delinquent adolescents find meaning in their lives and to continue their education by kindling within them a passion for glassblowing and, ultimately, for art and beauty.

Art Star

By the 1990s, Chihuly has achieved widespread recognition in Hollywood and Washington. President Clinton is photographed against a backdrop of *Macchias* when he delivers a speech in Seattle in 1993. In September 1994, Chihuly's painted shoes attract attention during a state dinner for Russian president Boris Yeltsin at the White House. As reported in *The New York Times*, guests assume the shoes are stained glass, but Chihuly replies that they are merely drippings of paint. In 1995, his *Cerulean Blue Macchia with Chartreuse Lip Wrap* is added to the White House American Crafts Collection. President and Mrs. Clinton become fans and display Chihuly's artwork in their private quarters at the White House.

In 1996, he creates a fantasy environment—including *Persian Pergola*, five *Chandeliers*, and *Anemone Wall*—for the Academy of Motion Picture Arts and Sciences Governor's Ball that follows the Academy Awards ceremony in Hollywood. A number of celebrities, including Elton John, Jack Nicholson, and Bill Gates, collect his work and have made the trek at one point or another to the Boathouse to watch Chihuly create in front of the fire. The artist's work even begins to appear on television (e.g., many episodes of *Frasier*) and in the movies. With all this exposure, Chihuly decides it is time to do something truly spectacular and to raise his profile even higher. This leads to the show-stopping, wildly ambitious project that becomes known as *Chihuly Over Venice*.

Chihuly with artist David Hockney. c. 1989

Sound Byte:
"Why do people want to collect glass? Why do they love glass? For the same reason, I suppose, that many of us want to work with it. It's this magical material that's made with human breath, light goes through it, and it has this incredible color. Plus, it breaks. And I think the fact that it breaks is one of the reasons that people want to own it."
—DALE CHIHULY, 1998

85

Chihuly Over Venice

During a mid-1996 interview on National Public Radio Chihuly responds to an interviewer's question of "Why glass?" with "Suppose a child comes upon some beach glass with sun on it. The little kid will drop everything to grab that glass. Maybe I'm that little kid." In his day-to-day life, Chihuly can playact a child who is sometimes spoiled, sometimes naughty, sometimes angelic. But in *Chihuly Over Venice*, the artist playacts a young man who consciously relives his memories from 1968, the year of his trip to Venice.

Sound Byte:
"I always had an image of a chandelier hanging over a bridge and a couple of Italian ladies stopping to talk on the bridge. Then they might talk about it and tell other people. I imagine them liking it. I hope they do."
—DALE CHIHULY, 1996

Chihuly's concept for the project starts in the same way that one might plan a movie, with props being made in various locations that will eventually be brought together and merged into the final product. Chihuly's idea is to orchestrate a plan whereby his Seattle-based assistants work at venerable glass factories all over the world—in Nuutajärvi (Finland), in Waterford (Ireland), Murano (Italy), and

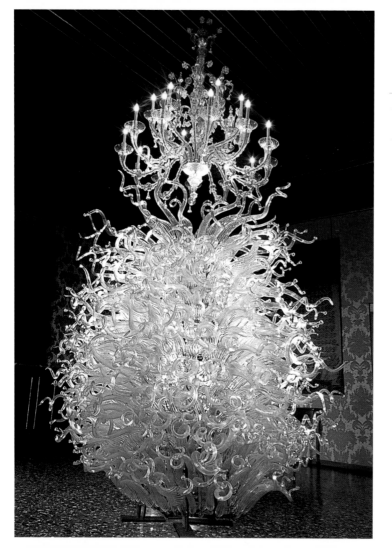

*Palazzo Ducale
Chandelier*
1996. 9 x 8'
Venice, Italy

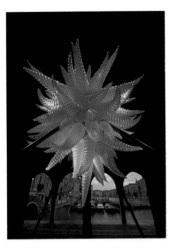

in Monterrey (Mexico), as well as in Seattle—with the ultimate goal of sending all of these beautiful objects to Venice. The individual glass components are then filmed in all their glittering array as large, assembled sculptures against the backdrop of Venetian canals, palazzos, and churches.

The Action heats up

During the *blows* around the world, he evolves new working styles: Since thousands of objects are needed for Venice, Chihuly insists that many of the components be completed without reheating them, since this not only saves time and adds a spontaneous edginess, but eliminates many steps in the process during which shapes are usually refined.

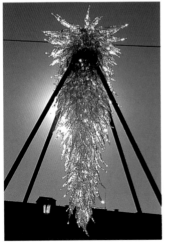

At each stop, Chihuly creates installations derived from the work made at the factory. Many team members speak of the *glass blow* in Nuutajärvi, Finland, as the high point of the project. Chihuly is really "on" during the session and seems to be everywhere at once at all hours, directing the team at the factory, bicycling around the town or down at the river, throwing glass into the water to see if it will float, and creating installations on the rocks.

Like tiny Nuutajärvi, the small-town character of Venice proves to be essential to the experience of *Chihuly Over Venice*, since it provides the hundreds of assembled visitors with an opportunity to visit the sculptures as if the latter were in their own backyards.

In August 1996, Chihuly ships nearly 12,000 component pieces of glass to Venice.

Wowing with the Doge

Chihuly is inspired at the Doge's Palace to place his sculpture, the *Palazzo Ducale Chandelier* (see page 87), directly beneath one of the palace's chandeliers. Just as he had attempted in his *Venetian* series to bring that "tradition" full circle, this sculpture brings to fruition the *idea* of the chandelier reaching from the floor to the ceiling in a perfect arc of closure. Built as an homage linking the ages, it signifies a marriage of time, circumstances, and respect.

Chihuly addresses the problem of the *finial* (i.e., the small ornamental tip) in abstract sculpture and of the ways in which a sculpture should *end* in order not to appear "decorative." With his *Chandelier* sculptures, the finials melt into the sculpture, and the sculpture and ornament become one. Each *Chandelier* ranges in length from two to 30 feet and consists of 30 to 2,800 hand-blown pieces attached to steel armatures or dangling from heavy-gauge chains. The awe-inspiring structures recall a Medusa head with electric-blue glass parts snaking away from

OPPOSITE TOP
Mercato del Pesce di Rialto Chandelier
1996. 8 x 5'
Venice, Italy

OPPOSITE BOTTOM
Campiello Remer Chandelier
1996. 12 x 5'
Venice, Italy

its core; when whimsical, they incorporate pieces shaped like frogs' toes, chili peppers, or sagging gourds. *Chihuly Over Venice* is a major large-team operation for Chihuly outside Seattle. Ultimately it involves more than 100 people. Tensions run high as deadlines approach, and the project is measured not in terms of weight but in dollars and in terms of the possible number of complications or embarrassment that might arise from loss, neglect, damage, and so on.

Chihuly's pioneering edge leads him to dismiss technology even as he overwhelms those around him with his use of cell phones, voice mail, cameras, and remote microphones. *Chihuly Over Venice* is a curious **blend of ancient and modern technology**: The dated practices of glassblowing come hard up against the innovations of high-definition television (HDTV), and, as a further juxtaposition of past and present, the camera crew is required to transport the high-tech equipment in an old wooden boat, trailing Chihuly and his team on the murky Venetian canals.

So what exactly is *Chihuly Over Venice*? The artist presents 14 *Chandeliers* as a thank-you to the city of Venice for its role in helping to launch his early career, but also to the collectors and others who have traveled to Venice to watch as the sculptures grow and take their place in the ensemble of buildings, people, water, and the light of the city. The sculptures create a breathtaking panorama at night as they dominate the maze of watery, palazzo-lined canals.

Dale's way

This spectacle reveals the Chihuly spirit: He is compelled to *besiege* you, right now, all at once—*Look at this! Look at that!* And just when you become overwhelmed by his work, Chihuly is gone: Maybe he's back there, in the hotshop, with the glassblowers, taking inspiration from them; or maybe he's splashing in the tub; or perhaps he has retreated to work his voice mail.

> **FYI: Voice mail, Chihuly-style**—You are not a player in Chihulyland unless you have a mailbox and password to one of the world's most unusual voice-mail systems. Chihuly broadcasts "all points bulletins" to keep his far-flung teams of installers and staff in the loop, sometimes to the accompaniment of water splashing in the background as he calls from the hotel tub. He boasts that, wherever he is in the world, he can come up with an idea in the morning and have it fabricated the same day at his studio in Seattle. Several of the far-flung consultants treat voice mail like talk radio, exchanging up to 10 or 20 messages on the speaker phone over a cup of coffee. Mock battles are waged over the telephone lines as various groups hammer out conflicting schedules or search for such resources as mountain climbers or equipment for a major installation.

Though *Chihuly Over Venice* was a temporary extravaganza, it was recorded in HDTV and the Chihuly archives contain tens of thousands

of slides from the project. It became a PBS pledge special and was re-created later as a museum show in the United States. It drew huge crowds at its many venues.

Great Commissions

As the economy of the 1990s kicks into high gear, Chihuly finds himself with ever-larger numbers of clients eager for permanent installations. The purchase and renovation of the Ballard Building in Seattle in 1997 allow him to create full-size mock-ups for commissioned works. The team first constructs a model of the architecture where the piece will be displayed, then they begin the creative process of assembling the chandelier parts and solving the scale and lighting issues, as they do with two *Chandeliers* for the cruise ships *Disney Magic* and *Disney Wonder*. Chihuly builds a full-scale mock-up of the grand salon of an ocean liner, then begins creating the *Chandeliers* for it. In 1998, he installs two large *Chandeliers* at Benaroya Hall, the Seattle Symphony's new home.

Puttin' on the Bellagio

Chihuly's largest sculpture of the 20th century, the spectacular *Fiori di Como*, is permanently installed above the lobby of the luxurious Bellagio Resort in Las Vegas. The 2,000-piece canopy soars like an enchanting veil of glass over the comings and goings of people below it.

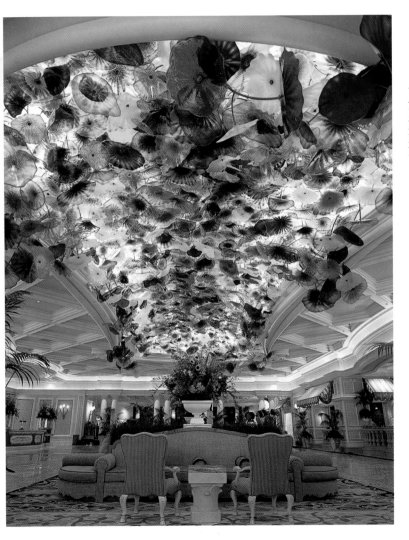

Fiori di Como
1998
Bellagio Resort
Las Vegas
Nevada

Niijima Floats

In 1997, Chihuly travels with his team of glassblowers to Niijima, Japan, to participate in the tenth Annual International Glass Arts Festival, where he launches a group of *Floats* into the ocean during a typhoon. Like gigantic hollow marbles, the *Niijima Floats* are created with richly colored glass and feature surface treatment such as crinkly gold foil wraps, playful spirals, and "jimmies" that stud the spheres like rubies and sapphires. Lit from the inside with neon, the *Floats* glow with vivid, Technicolor hues. Lit from the outside by sunlight or halogen lights, they boast deeply rich colors. Often placed on black granite surfaces, reflecting pools, or lawns, *Niijima Float* installations are suited for flat, open spaces, either in- or out-of-doors.

Blessing of a lifetime

On February 12, 1998, Chihuly and Leslie Jackson become the proud parents of a son, **Jackson Viola Chihuly**. Nicknamed "Mighty Mouse," the much-adored child bears a striking resemblance to Chihuly and has the good fortune of being taken everywhere by his parents. In his first 18 months of life, Mighty

Dale with Jackson Viola
Chihuly and Leslie Jackson
1998

Mouse amasses a huge number of frequent-flyer points from having traveled on nearly 80 plane flights! When separated from his son, the proud father faxes drawings to Mighty Mouse from around the world, sketching out his dreams and plans in a style that is part children's bedtime story, part daily journal.

Jerusalem 2000

Chihuly's most ambitious project since Venice is *Chihuly in the Light of Jerusalem 2000*, a celebration of two millennia—the one ending in 1999, the other beginning in 2000. *Jerusalem 2000* is installed in June 1999 at the Tower of David Museum in Jerusalem, just inside the walls of the old city, and remains there through the year 2000. *Crystal Mountain*, the center-piece of Chihuly's gleaming creation, is 44 feet tall and consists of tons of raw steel, sharp edges, and sparkling, glasslike chunks. The crowds find that the best time to view it is when the sun is low at the walls and the knitted web of crystal becomes translucent.

Central to the *Jerusalem 2000* project is a sculpture called the *Blue Tower*. It is 48 feet tall and is formed by an arrangement of 2,000 fragile glass arms, each

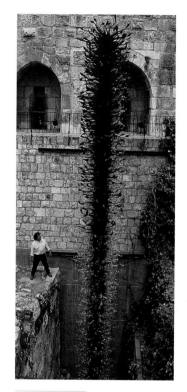

The artist views the *Blue Tower* at *Chihuly in the Light of Jerusalem 2000*

95

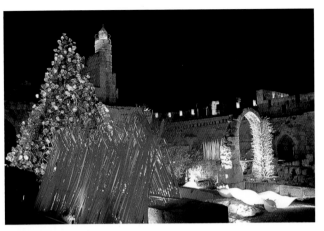

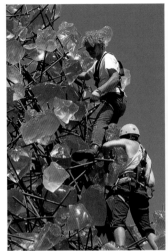

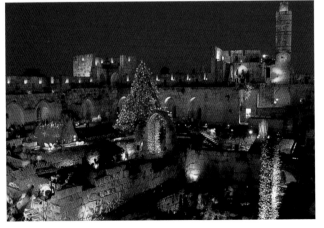

anchored into a metal armature. Perhaps the most beautiful aspect of the tower is its transformation from deep cobalt blue at the top to the palest imaginable sapphire crystal at its base deep within the excavation. It's as if Chihuly has applied to the top of the sculpture a watercolor wash that has the tint of the Jerusalem sky just before twilight. The wash slowly saturates the sculpture as it seeps toward the base.

More than twice the number of people arrive for opening night as had been expected. The startling colors of the glass, coupled with the looking-glass qualities of the *Niijima Floats* and with the trail of color leading the eye from the *Red Spears* to the *Crystal Mountain*, transform the Tower of David Museum into a garden of mythical proportions. Just as in the museum, where there is an elaborate 19th-century scale model of Jerusalem, so too Chihuly builds a model of paradise in the courtyard of the citadel—a paradise of green grass and red spears, but grass and spears purified by the fire of the furnace and transformed by the breath of the artist.

ABOVE
White Tower (detail) at *Chihuly in the Light of Jerusalem 2000*

OPPOSITE
Four views of *Chihuly in the Light of Jersualem 2000*

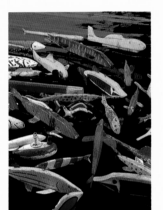

Since the 1980s, Chihuly has had an obsession with collecting. His interest grew when he started collecting old steamer trunks that he used for shipping glass around to galleries.

In Dale's words: "I don't know what it is about collecting, but *I love to collect things.* But I don't like to collect them individually. My preference is to buy things already collected by someone else.

One of the things I've collected over the last ten years is **chalkware**, little figurines made out of plaster of Paris or chalk that you could get at the carnival back in the 1920s, 1930s, and 1940s. You'd throw the baseball and hit the bottles and win the Kewpie doll. I love the fact that this chalkware was made on the road by the carnies. Even though they used the same mold, each one was painted differently.

I'm always looking. I run into things. I collect artwork as well. Mostly works on paper. I love to have a **drawing** or **watercolor** or a **collage** by a great artist, especially an artist that I relate to. I have a lot of great artists' drawings or watercolors—Titian and Picasso, and all kinds of contemporary artists as well.

I collect **canoes**. I love canoeing. The canoe is such an extraordinary form on the water, the way it moves across the lake and down the river. So I look for beautiful wooden canoes, and I hang them from the ceiling.

I hang exquisite **birdhouses** that for hundreds of years have been made in America and elsewhere. So when I find a great birdhouse, I hang it from the ceiling of the studio.

Recently I bought several hundred **accordions** to hang from the ceiling of one of the studios, and also for my library.

If you walk through one of my studios, you'll see that my biggest interest in collecting is **American Indian Art**. I have hundreds of baskets from the Northwest Coast, and hundreds of Pendleton blankets, and some Navajo blankets.

By far the greatest design ever done in the 20th century in this country was **American** cars, especially those of the 1950s. And so, being raised to that—there was hardly a kid who didn't love cars at that time—I've always had this love of automobiles, so I have a weakness for buying the occasional car or motorcycle. I collect Indian motorcycles as well."

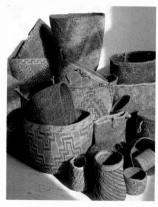

OPPOSITE TOP
Fish decoys

OPPOSITE BOTTOM
Carnival plasters

RIGHT TOP
Dale with basket collection. The Boathouse, Seattle Washington. 1993

RIGHT BOTTOM
Basket collection

The Iceman traveleth

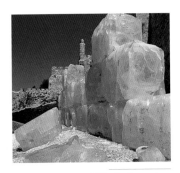

Chihuly Jerusalem Wall of Ice. 1999

As a young man, Chihuly had been deeply marked by his travels to the Middle East and to Venice. So, after working on *Chihuly in the Light of Jerusalem 2000*, Chihuly wishes to make a personal contribution to the peace process in the Middle East. In early October 1999, he returns to Jerusalem to erect a 64-ton *Chihuly Jerusalem Wall of Ice* directly in front of the ancient stone walls of the Old City of Jerusalem, near the Jaffa Gate. His hope is that a melting wall of ice might symbolize the melting of tensions between the Arabs and the Jews. He arranges to ship to Jerusalem approximately 30 solid blocks of ice of utmost clarity, each measuring 6' long x 3' deep x 4' high. The blocks are "quarried" in Alaska because the manmade ice there—known as Arctic Diamond—is so clear that one can read a newspaper through a three-foot-thick block of it. The ice is then shipped by rail and by barge to Tacoma, then again by rail across the continent, where it is loaded aboard a ship bound for southern Italy, transferred to a boat headed for Haifa, and finally craned into place outside the old city wall near the Jaffa Gate in Jerusalem.

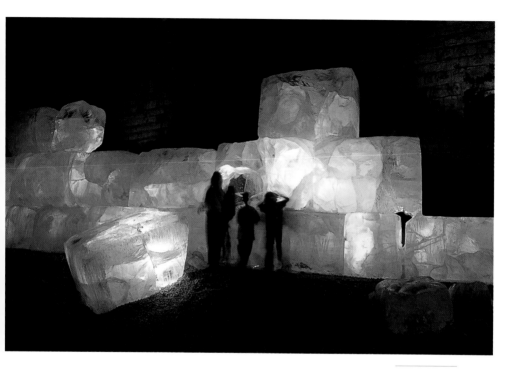

Chihuly Jerusalem
Wall of Ice. 1999

Overwhelming Response

Responding to popular demand, officials at the Tower of David Museum begin a "Chihuly at Night" program that draws 4,000 to 5,000 paying guests each evening between 7:00 and 11:00 P.M. Some visitors return as often as seven times. The *Chihuly Jerusalem Wall of Ice* attains instant cult status during the three days it takes for the ice to melt in the nearly 90-degree desert heat: Some people take chunks home to pray for an end to the drought; others use ice samples for making homeopathic medicine; children carry trays of ice up to the old city to display like trophies.

Into the 21st Century

Dale Chihuly is a contrary man. At a time when beautiful creations are often derided by cynics in the art world as being "low art," he plunges ahead in his mission to produce beautiful works of glass. For Chihuly, art is not about "prettiness" or about objects that belong in museums; he sees art as a living, vibrant part of everyday experience. Like Tiffany, Chihuly integrates his art into the external environment through installations that he makes throughout the world. What makes Chihuly the most innovative installation artist of his era is the almost sacred role that beautiful objects play in his installations, not to mention the life these objects take on after the installation is dismantled.

"High Art" vs. "Low Art"

Has Chihuly succeeded as an artist? The work remains controversial. People call him, not always as a compliment, the rock star of the art world. Crowds wait for hours to see his ambitious installations worldwide, and museums that show his work (his pieces reside in more than 175 collections) frequently break attendance records.

Acceptance by critics and connoisseurs has not been unanimous. Some critics have described him as a *conceptual artist*, because he is keenly interested in processes and ideas. Others have disdained him as a craftsman whose works are sugary, facile, and endlessly garish. But make no mistake: Art critics, often amazed by their own knowledge, tend to write for themselves, not for the general public. In fact, they often have a kind of "let-the-public-be-damned" attitude toward artists who create for the people and not for a cultural elite. American illustrator **Norman Rockwell** (1894–1978) was similarly scorned by the art establishment, even though millions of people continue to love his work long after his death. Shakespeare, too, created for the people, not for elitists or the nobility. Art purists feel antsy about Chihuly's marketing and public relations prowess, and are uncomfortable with his crossover to what they deem to be grandiose installations. They fault him for his alleged excess of gesture, mannerist-baroque forms, enormous scale, and industrious, combative, promotional behavior.

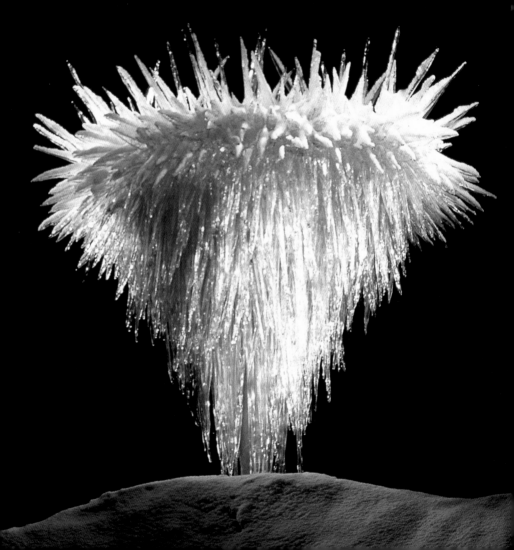

Sound Byte:

"His pieces are absolutely extraordinary artistic creations—ravishing."

—Jeremy Adamson, senior curator, Renwick Gallery,
Smithsonian Institution, December 1999

What the critics forget, however, is that Chihuly has succeeded in blending technology and "low" culture to expand a traditional form (i.e., *functional* glass) into the realm of high culture (i.e., *art* glass). They forget that his glass brings joy to millions of people through its unpredictable shapes, rich palette of colors, and the endless surprises of style. They ignore that his work is uplifting, never ironic or cynical, and that it causes people to smile with delight. They seem oblivious to the knockout factor in Chihuly's work: Viewers take one look at his work and go *Wow!!!*

Chihuly creates work that people want to own and to collect. His work with fragile glass makes us appreciate the delicacy of the beautiful and inspires us to protect it from destruction. And regardless of what the critics say, the final decision about Chihuly's success as an artist rests in your hands, not theirs. People all over the world, of all ages, races, and ethnic origins, love his work and collect it.

OPPOSITE
Icicle Creek Chandelier
1996
12 x 9 x 6'
Sleeping Lady
Retreat
Leavenworth
Washington

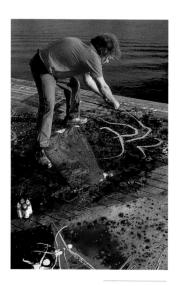

A Fascination with "series"

Chihuly enjoys the challenge of repeating specific types of works as parts of *series*, continued over long intervals of time. While the glass objects and nuances of color change substantially over the years, the series names and essential "skeletons" often remain the same: *Cylinders* retain their shape but might carry a blanket or figural image, increasingly distorted or abstracted; *Seaforms* are blown into a mold and take on a ribbed or undulating edge; *Macchias* are defined by wild patterning of spotted colors but have grown larger over the years; *Venetians* and *Persians*, named after traditional glassmaking centers, have become more ornate or baroque.

One of the reasons for these changes within each series is that new glassblowing teams have their own take on the series and perform their work in different locations. Blowing in a tiny studio in Japan is vastly different from blowing in a huge industrial factory in Finland.

ABOVE
Dale drawing and painting on the deck at the Boathouse Seattle, Washington. 1993

OPPOSITE
Columbia River Project Eastern Washington State 1998

His major Innovations

Chihuly is a true virtuoso, a man of talent, skill, bravura, ingenuity, power, boundless enthusiasm, and passion.

106

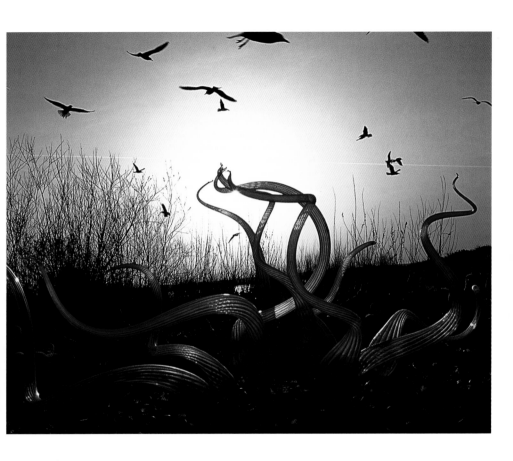

Conductor and choreographer, he has broken new ground by being one of the first American artists to have his ideas enacted through a team. By maintaining artistic control over this team, Chihuly successfully directs them as an extension of his own eyes, hands, and spirit. He has a "perfect pitch" for the scale of a project, always knowing whether he needs three people for a small glassblowing team or 30 for a major installation. He prefers to work with smaller glass components that can be built into larger structures: tiny baskets within baskets, giant chandeliers made from small, blown bubbles, and so on. He enlarges the scale of each series by periodically revisiting and remaking that series, playing with the scale of time (i.e., bringing to the series what he has learned since its earlier version) and with the scale of size. Part of his greatness lies in his ability to transform everyday materials such as glass and ice into objects of beauty.

OPPOSITE
Detail of
*Aventurine
Green and
Yellow Macchia*
1981

The key points to remember about Chihuly's genius are his:

- Use of **light**: He is a *luminist* who uses glass as a literal and metaphorical prism through which he projects intense theatrical light. This results in sublime, luminous effects and abstract expressions.

- Use of **color**: He has a distinct, painterly approach to glassblowing and is fascinated by the effect of the passage of light through glass that is made opaque by joyous, delirious colors.

- Use of **line and motion**: The zigzagging layers of glass and color are enhanced by a swirling frenzy of "moving" lines.

- Sense of **theatricality**: The style of his work evolves through an obsession with energy and the forms that manifest it.

- Five major **conflicts**: The creative tension in virtually all of Chihuly's work stems from the conflicts between East/West, forest/sea, masculine/feminine, expressive/decorative, and provincial/cosmopolitan.

- **Innovative marketing techniques:** From limited-edition series to his own publishing house, Portland Press, Chihuly exhibits dynamic marketing savvy.

- Love of **fragility**: Chihuly knows that the finest expression of beauty brings with it an awareness of beauty's fragility. He creates an almost unbearably exquisite sense of beauty by stretching glass until it seems on the verge of breaking. His objects seem almost too fine to survive. They embody and convey ecstasy. They delight our eye and dazzle our emotions. Each of his objects has been shaped by split-second decisions, with little room for error.

His Legacy

As a *creator*, Chihuly has singlehandedly paved the way for glass to be known as a medium for art. He has done this by exhibiting in a wide range of museums internationally and by reaching a large group of art

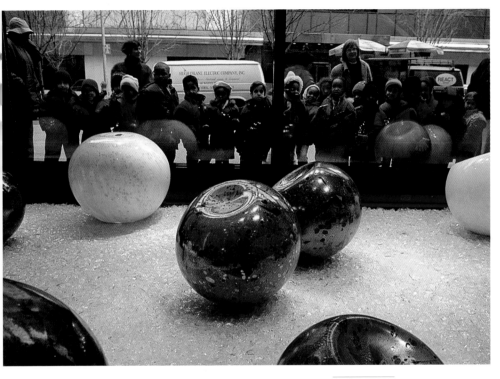

Niijima Float Installation
1991
American Craft Museum
New York, New York

Chihuly with Leslie Jackson and their son Jackson Viola Chihuly 1999

dealers and collectors—but also because his creations are so hauntingly beautiful that people are mesmerized by them and want to see more and more. The glassblowers refer to him as the wind in their sails. As an *educator*, he has gifted the world with the Pilchuck School, an unrivaled training ground for future glass artists. As a *humanist*, Chihuly has given generously of his time, energies, and money to the Hilltop Program for at-risk teenagers, as well as to Seniors Making Art and other similar programs. As a *team leader*, Chihuly has brought work to thousands of colleagues and employees throughout the world. As a *father*, Chihuly has radiated an unconditional love that most children can only hope for. As a *friend and companion*, Chihuly is a true mentor.

Chihuly's gift to the world

So this is Dale Chihuly. He invites us to dream, to enjoy beauty, and to believe that childhood can last forever. When looking at his continually surprising creations, follow your intuition rather than your intelligence; go with your heart, not your brain. Chances are, when you experience these luminous marvels, you'll beam with joy. His art will transform you. Your soul will glow. And now that you've had a taste, you'll probably want more.